VANDERBILT
OF LONG ISLAND

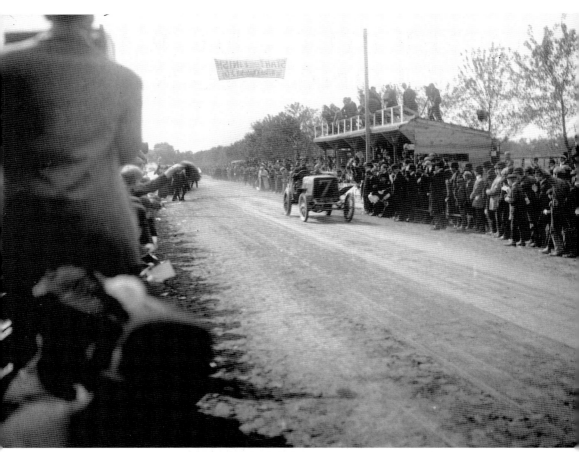

The first Vanderbilt Cup Race was won by George Heath in a French Panhard in 1904. (Courtesy of the George Eastman House.)

On the front cover: Driver George Robertson and his mechanician Glenn Ethridge drive the No. 16 Locomobile around the Westbury turn in the 1908 Vanderbilt Cup Race. (Courtesy of Brown Brothers.)

Cover background: "Old 16" wins the 1908 Vanderbilt Cup Race in front of the Hempstead Plains press and officials stand on the Long Island Motor Parkway. (Courtesy of Brown Brothers.)

On the back cover: Driver William Luttgen refuels the No. 5 Mercedes as referee William K. Vanderbilt Jr. watches in 1908. (Courtesy of Brown Brothers.)

VANDERBILT CUP RACES
OF LONG ISLAND

Howard Kroplick
Foreword by Florence Ogg

Copyright © 2008 by Howard Kroplick
ISBN 978-0-7385-5751-9

Published by Arcadia Publishing
Charleston SC, Chicago IL, Portsmouth NH, San Francisco CA

Printed in the United States of America

Library of Congress Catalog Card Number: 2007933990

For all general information contact Arcadia Publishing at:
Telephone 843-853-2070
Fax 843-853-0044
E-mail sales@arcadiapublishing.com
For customer service and orders:
Toll-Free 1-888-313-2665

Visit us on the Internet at www.arcadiapublishing.com

This book is dedicated to three people who inspire me to share my passions:
my wife, Roz, and our daughters, Deborah and Dana.

CONTENTS

Acknowledgments		6
Foreword		7
Introduction		9
1.	William K. Vanderbilt Jr.	11
2.	The 1904 Vanderbilt Cup Race	21
3.	The 1905 Vanderbilt Cup Race	39
4.	The 1906 Vanderbilt Cup Race	57
5	Long Island Motor Parkway	81
6.	The 1908 Vanderbilt Cup Race	87
7.	The 1909 Vanderbilt Cup Race	103
8.	The 1910 Vanderbilt Cup Race	113

ACKNOWLEDGMENTS

I would like to thank the many people and organizations that made contributions to this book: Helene Abramowitz, Cathy Ball, Sam Berliner, Wallace Broege, Deborah Copeland, John Cuocco, Guy Frost, the George Eastman House, Jerry and Linda Helck, the Henry Ford, Harrison Hunt, Joyce Kalleberg, Dana Kroplick, Phil Kroplick, Roz Kroplick, Sandi Lusk, Betsey Murphy, the Nassau County Department of Parks, Recreation and Museums–Cedarmere, the National Automotive History Collection at the Detroit Public Library, the New Jersey Historical Society, Florence Ogg, Jim Poole, Karyn Reinert, Tom Sherry, the Suffolk County Historical Society, the Suffolk County Vanderbilt Museum, the University of California, Riverside, Al Velocci, and Maryann Zakshevsky. Unless otherwise noted, images are from the collection of Howard Kroplick. Special thanks to Mark Dill for his editorial assistance in organizing these materials.

FOREWORD

The history of sports on Long Island could not be complete without including the automobile races encouraged and organized by William K. Vanderbilt Jr. From 1904 to 1910, the Vanderbilt Cup Races attracted international competitors and provided the American public with excitement, daring, and glamour. The first three races were held on Long Island public roads. The Long Island Motor Parkway—the first road in the United States built exclusively for automobiles—comprised a portion of the courses used for the 1908 to 1910 races.

Documenting this part of history has been a passion for Howard Kroplick. For over five years, he has researched the Vanderbilt Cup Races and collected more than 24,000 images, 2,500 reference sources, and over 150 pieces of memorabilia. As a research volunteer, he had the opportunity to examine the archives at the Suffolk County Vanderbilt Museum and has included many of these images in this book.

For the centennial celebration of the first race in 2004, Howard Kroplick generously shared his research material and presented a lecture at the Suffolk County Vanderbilt Museum. In 2004 and 2005, he also donated images from his collection, which were included in special museum exhibits.

The Suffolk County Vanderbilt Museum regards Howard Kroplick as one of the world's leading authorities on the races. His collection of material relating to the Vanderbilt Cup Races is an invaluable reference source to researchers interested in early automobile racing and the history of Long Island.

<div align="right">
Florence Ogg

Director of Collections and Archives

The Suffolk County Vanderbilt Museum
</div>

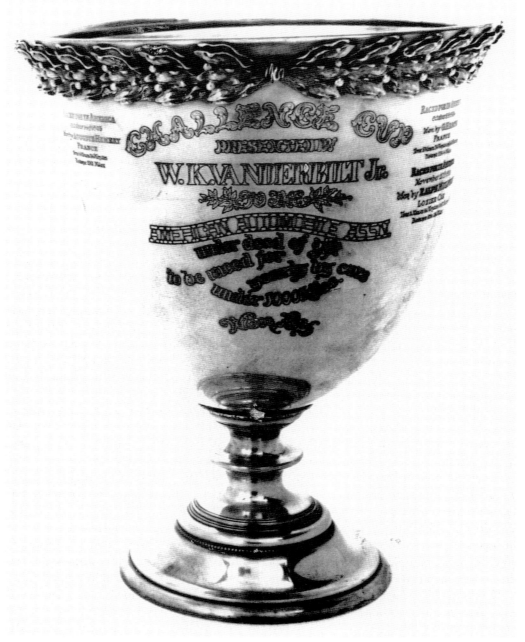

The 10.5-gallon Tiffany cup donated by William K. Vanderbilt Jr. contains 30 pounds of silver. The cup is currently at the Smithsonian Institution in Washington, D.C. (Courtesy of the Suffolk County Vanderbilt Museum.)

INTRODUCTION

The inaugural William K. Vanderbilt Jr. Cup Race in 1904 was the first major international automobile race in the United States. Although Vanderbilt was only 26, he was heir to a transportation fortune and had figured prominently in automobile racing for nearly 10 years since sponsoring automobile races as a teenager.

His enthusiasm for automobiles drew him to the fastest machines available, competing in Europe's biggest early road races just after the dawn of the 20th century. In Newport, Rhode Island, and Lake Success, New York, he earned the scorn of his neighbors and police with his wild rides on dusty roads that most people still thought of as paths for horses and foot traffic.

"Willie K.," as friends called him, had a vision born of his racing experiences in Europe. He saw how the European automobile manufacturers were further advanced than their American counterparts, and he decided to challenge the home automobile industry to respond. The product of this vision was a 30-pound silver loving cup embossed with an image of Vanderbilt's proudest moment behind the wheel: his dramatic one-mile world land speed record run of 92.3 miles per hour on January 27, 1904, at Ormond-Daytona Beach, Florida. His dream of a confrontation between teams from the major automobile-producing nations of France, Germany, Italy, and the United States was realized on Long Island with the release at dawn of a red Mercedes as the first starter in an international field of 18 machines on October 8, 1904.

What followed over the next six years was a tumultuous spectacle of romance, intense competition, and reckless danger. With a course charted on Long Island, the first race in 1904 began in controversy as the sons of high society commandeered public tax–funded roads for their sport in the face of protests from the rural community's largely farmer population.

The spectacle proved grander than even Vanderbilt could have envisioned, attracting upward of a quarter of a million people in subsequent years. They crowded the roads to form accordion-style human tunnels that expanded to barely accommodate thunderous, 2,000-pound, nearly brakeless cars driven at the brink of control. Still, the economic boon to the community of hoards of free-spending visitors won over Long Island residents and convinced Nassau County supervisors to approve the use of roads for the sport. The success of the first race attracted the greatest cars and drivers from around the world for the 1905 race, including Louis Chevrolet and Vincenzo Lancia.

The death of a spectator nearly brought the classic to a premature demise in 1906. The marvel was that only one spectator had been killed in the three races up to that time. Demonstrating vision again, Vanderbilt charted the goal of a private concrete-paved highway, the first in the nation built exclusively for automobiles. His dream was of a safe, smooth, police-free road without speed limits and a place where he could conduct his beloved international race without spectators running onto the course.

The Long Island Motor Parkway, Inc., was born with Vanderbilt as president and his trusted right-hand man, A. R. Pardington, as general manager. Like his great race, Vanderbilt's vision

of a grand thoroughfare 50 miles long and 100 feet wide between New York City and Riverhead was in some ways a reach beyond his grasp. Pardington worked incessantly to secure rights-of-way across private fields. Many landowners resented the supposition that a promise of economic growth delivered by the great road should be compensation enough for the use of their property. Continual complications and delays forced a cancellation of the Vanderbilt Cup Race in 1907.

The challenges facing the Long Island Motor Parkway were so great that only an eight-mile stretch was incorporated into the 1908 course. There would never be a contest for the Vanderbilt Cup conducted exclusively over the Long Island Motor Parkway. Despite the proven danger of unruly crowds, the races again included largely uncontrollable public roads.

In addition to the challenge of crowd control, more controversy surfaced with a power struggle between the two major American race-sanctioning bodies of the day. The American Automobile Association (AAA), which organized the Vanderbilt Cup Race, and the Automobile Club of America (ACA), acknowledged in Europe as the sanctioning body of international races, became embroiled in a dispute over rules regulating the cars. The ACA announced in 1908 a new international race in Savannah, Georgia, and the character of the Vanderbilt Cup Race was abruptly changed.

Never again would the greatest cars and drivers of Europe return to contest for the Vanderbilt Cup, but the legend of the great race continued to grow. Three years of French dominance ended with George Robertson's victory with the Connecticut-manufactured Locomobile racer in 1908. It was heralded as America's first great triumph over foreign marques like Isotta, Mercedes, and Hotchkiss, albeit all privately owned by Americans and none entered by the manufacturers. In 1909, the race transformed into a contest for stock cars and was panned in newspapers as a dull, poorly attended event.

In 1910, the race had a resurgence that proved its undoing. The massive, big-bore racers returned with the break-of-day start that compelled attendees to spend the entire night before in Long Island, drinking and dancing at hotels or around campfires. Although the great European drivers did not return, a new crop of highly skilled American speed demons provided plenty of excitement. The result was marvelous competition with deadly consequences. While the early course configurations approached 30 miles, the 1910 event was compacted into 12.64 miles. The Long Island Motor Parkway made up only 5.15 miles of that total, giving approximately 250,000 people in attendance virtually unrestricted access to 7.49 miles of public roads. By day's end, American Harry Grant and his stock car Alco had won the race for the second consecutive time, but the cost to human life was excessive. Two riding mechanicians were dead, and several spectators were injured.

The end finally came to racing for the cup on Long Island roads. For years the drivers had protested the danger of plunging through the living walls of people during their wheel-to-wheels duels. They were past settling for promises of reform. They simply refused to return to race on Long Island. While Vanderbilt continued to commission his cup at other venues through 1916, the heart and soul of the contest died with its disappearance from Long Island.

Vanderbilt's races introduced America to big-time motor sport and helped focus the nation's automobile industry on improving its products. The classic race's departure from Long Island was the end of an era. The sport passed on to subsequent generations that could never create or endure the challenges of what were the Vanderbilt Cup Races in rural Long Island at the dawn of the industrial age.

1

WILLIAM K. VANDERBILT JR.

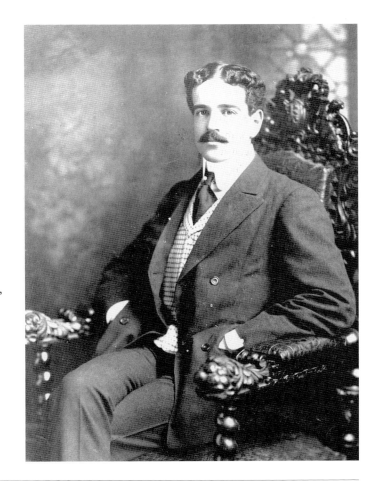

William K. Vanderbilt Jr. (1878–1944) was the great-grandson of Commodore Cornelius Vanderbilt, who built a transportation empire in shipping and railroads. Known to his friends as Willie K., he was the second child and first son of William K. Vanderbilt (1849–1920) and Alva Erskine Smith (1849–1933). He was a railroad executive, an accomplished yachtsman, and a pioneer automobile racing driver. At the age of only 26, William K. Vanderbilt Jr. proposed the first international road race to be held in the United States by donating the Vanderbilt Cup. (Courtesy of the Suffolk County Vanderbilt Museum.)

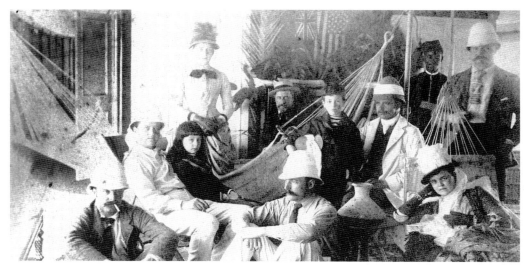

At the age of nine in 1887, William K. Vanderbilt Jr. went on a trip up the Nile River on the steamer *Prince Albas* chartered by his father from Thomas Cook and Son. On board were family, friends, nannies, and his future stepfather: from left to right, (first row) Oliver Hazard Perry (O. H. P.) Belmont, F. O. Beach, and Alva Vanderbilt; (second row) William K. Vanderbilt, William K. Vanderbilt Jr.'s 10-year-old sister Consuelo Vanderbilt, William K. Vanderbilt Jr., and Dr. Francis Johnson; (third row) M. Kulp, Capt. Henry Morrison, and W. S. Hoyt. In 1895, William K. Vanderbilt and Alva Vanderbilt divorced after 20 years of marriage. Nine years after the Nile cruise in 1896, Alva married family friend O. H. P. Belmont in New York City. (Courtesy of the Suffolk County Vanderbilt Museum.)

William K. Vanderbilt Jr. was educated by private tutors and then attended St. Mark's Preparatory School in Southborough, Massachusetts, from 1894 to 1896. He loved competitive sports and was a member of the football team (first row, far right). (Courtesy of the Suffolk County Vanderbilt Museum.)

William K. Vanderbilt Jr. entered Harvard University in 1897. He became business manager of the *Advocate*, the literary magazine of the undergraduate school, and joined the Alpha Delta Phi fraternity (first row, far right). As a sophomore, he joined the Institute of 1770, which claimed to identify the 100 members of the Harvard class most fit for society. However, after meeting his future wife, he did not complete his second year at the university. (Courtesy of the Suffolk County Vanderbilt Museum.)

In 1898, Vanderbilt met Virginia Graham "Birdie" Fair (1875–1935), a Newport, Rhode Island, neighbor. Virginia was the daughter of Sen. James Graham Fair, who with James Flood, William O'Brien, and John Mackay amassed a fortune from the Nevada Comstock Lode. On April 4, 1899, the couple married in New York City. They spent their honeymoon at Vanderbilt's father's Idle Hour country estate in Oakdale but were forced to flee the home as it nearly burned down.

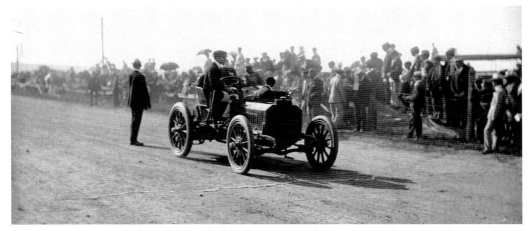

After his marriage, William K. Vanderbilt Jr. was an independent adult and ready to embrace another passion, automobiles. In 1900, he purchased, at the cost of $10,000, one of the first racing cars imported in the United States, a 28-horsepower Daimler nicknamed the *White Ghost*. On September 6, 1900, Vanderbilt and his society sporting friends gathered at a half-mile Aquidneck Park horse track near Newport, Rhode Island, for a series of automobile races. Vanderbilt won 3 of the featured 13 five-mile races with an average speed of 33.7 miles per hour. The following year, he returned to compete in the Aquidneck Park, winning both the 5-mile and 10-mile races in his 35-horsepower Mercedes *Red Devil* shown above. (Courtesy of the George Eastman House.)

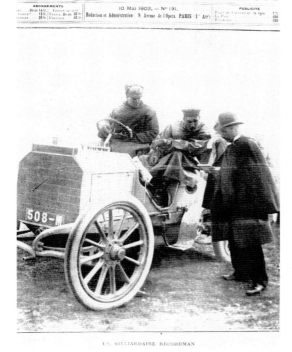

From 1902 to 1903, Vanderbilt and his wife traveled throughout Europe. Here he found magnificent open roads to drive as fast as he dared and an education in the new sport of automobile racing. On May 2, 1902, he set the world's kilometer record in a 40-horsepower Mercedes, averaging 110 kilometers per hour or 68.4 miles per hour. He was hailed in the French magazine *La Vie Au Grand Air* as "Un Millionaire Recordman." He earned an impressive third place in the 1902 Belgian Circuit des Ardennes race, competing against the world's best road racers. (Courtesy of the Suffolk County Vanderbilt Museum.)

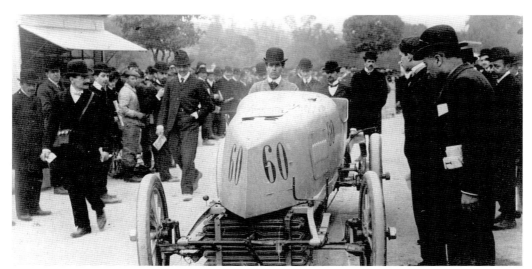

Vanderbilt returned to Europe in May 1903 to compete among 216 cars in the infamous Paris-Madrid Race driving his 80-horsepower Mors. While it must have been disappointing at the time, a cracked cylinder on the first day of competition spared him exposure to the numerous accidents that earned the event the name "Race to Death." At least eight people were killed during the race, including car maker Marcel Renault, ending the first great era of motor racing, the European city-to-city races on open roads.

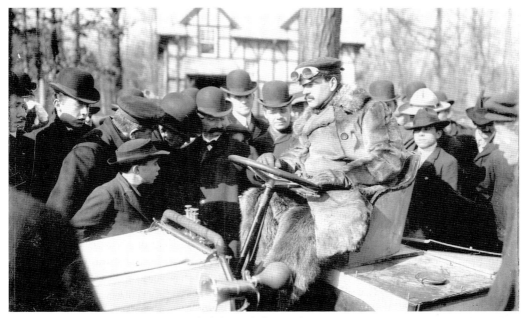

On Thanksgiving Day 1903, Vanderbilt took his 60-horsepower Mors to West Orange, New Jersey, and won the Eagle Rock Hill Climbing Contest. He broke the record time for the steep, curvy, one-mile hill. After his victory, crowds surrounded Vanderbilt, who wore a fur coat to protect against the wind while driving. (Courtesy of the George Eastman House.)

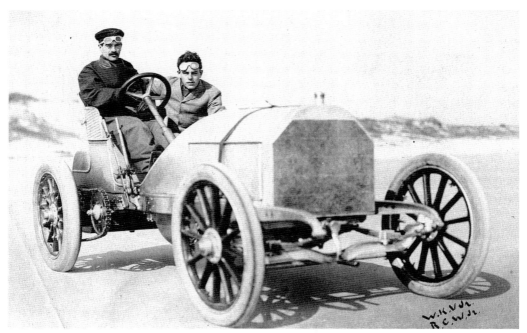

The zenith of William K. Vanderbilt Jr.'s racing career was the Ormond-Daytona Beach Automobile Tournament in January 1904. For the event, he purchased a giant 90-horsepower Mercedes, among the most powerful cars in the world. On January 27, he set the one-mile land speed record on the beach going 92.3 miles per hour, surpassing the record established earlier in the month by Henry Ford. (Courtesy of the Suffolk County Vanderbilt Museum.)

Vanderbilt was the star of the 1904 four-day race meet, winning 9 of 10 races. His only loss was to America's first major professional driver, Barney Oldfield, in a one-mile drag race. Newspapers and magazines hailed Vanderbilt as the leading automobilist in the world. (Courtesy of the Suffolk County Vanderbilt Museum.)

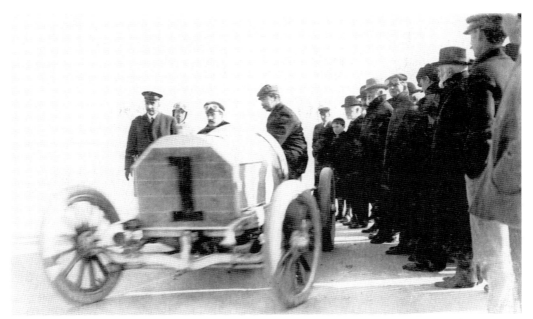

Vanderbilt returned to Ormond-Daytona Beach in January 1905 in a new 90-horsepower Mercedes, one of his final forays as a racing competitor. However, the 1904 champion was dethroned, failing to win a single race. His one-mile land speed record was also broken by Louis S. Ross, who drove a Stanley Steamer. (Courtesy of the National Automotive History Collection at the Detroit Public Library.)

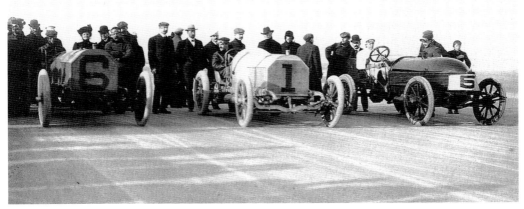

At Ormond-Daytona Beach in 1905, Vanderbilt competed for the Dewar Trophy one-mile championship. Three cars ready to start the race are, from left to right, E. R. Thomas in the No. 6 Mercedes, William K. Vanderbilt Jr. in the No. 1 Mercedes, and A. E. McDonald in the No. 5 Napier. (Courtesy of the Suffolk County Vanderbilt Museum.)

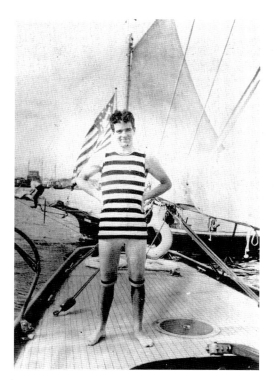

William K. Vanderbilt Jr. separated from his wife Virginia in 1909, eventually divorcing 18 years later. After the separation, he traveled throughout the world collecting rare specimens for his marine museum at his Long Island Eagle's Nest summer estate in Centerport. Here, in his 20s, he is shown enjoying the sun on his sailboat. (Courtesy of the Suffolk County Vanderbilt Museum.)

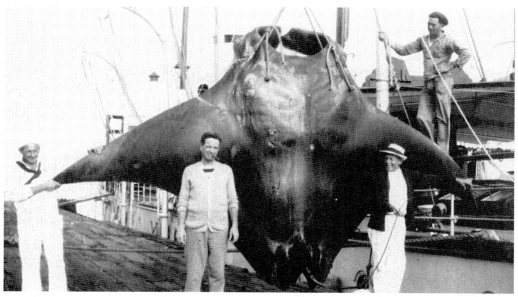

In 1920, William K. Vanderbilt Jr.'s 71-year-old father, William K. Vanderbilt, died at his home in Paris. His will provided $21 million to each of his sons, William and Harold. Known now as William K. Vanderbilt II, in January 1922, he bought a 213-foot diesel yacht, which had served in the French army as a sloop of war. While on the *Ara*, he and his crew captured this giant stingray. (Courtesy of the Suffolk County Vanderbilt Museum.)

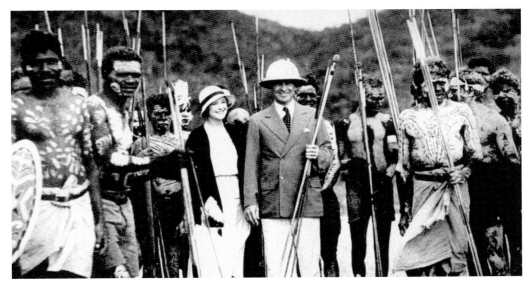

On September 5, 1927, Vanderbilt married Rosamond Lancaster Warburton, whose previous husband was related to merchant tycoon John Wanamaker. They traveled throughout the world in their new cruise ship, the luxurious 265-foot *Alva*, named for his mother. Aborigines greeted them in 1931 at Great Palm Island in Queensland, Australia. (Courtesy of the Suffolk County Vanderbilt Museum.)

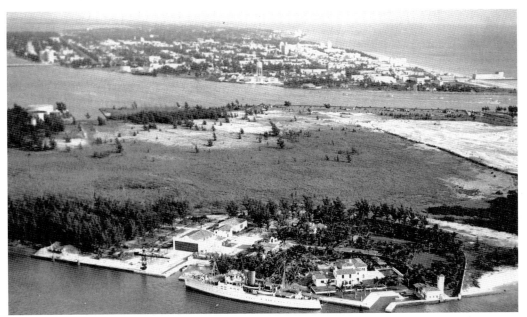

Vanderbilt purchased a nine-and-three-fourths-ton Sikorsky S-43 amphibian seaplane in 1936. He used the Sikorsky to fly back and forth to his winter home, Alva Base at Fisher Island near Miami, Florida, which included an aircraft hangar, a mooring dock for the *Alva*, and an 11-hole golf course. (Courtesy of the Suffolk County Vanderbilt Museum.)

On January 8, 1944, William K. Vanderbilt II died of a heart ailment at age 65. He received many tributes from his family, friends, automobile enthusiasts, yachtsmen, aviators, and World War I navy comrades. In his will, Vanderbilt left a trust fund of $2 million to care for his Eagle's Nest estate in Centerport and arranged for its presentation to the local county government. His home is maintained today as the Suffolk County Vanderbilt Museum.

2

THE 1904 VANDERBILT CUP RACE

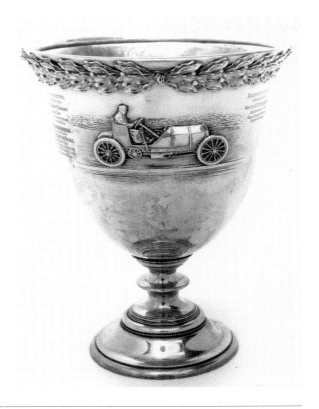

At the beginning of the 20th century, the superiority of European automotive craftsmanship cast a long shadow over America's fledgling car industry. To encourage American automobile manufacturers to challenge European quality, William K. Vanderbilt Jr. envisioned America's first international road race. On January 8, 1904, the 26-year-old Vanderbilt proposed that officials of the newly formed American Automobile Association (AAA) bring such a race to his native Long Island. He donated a 10.5-gallon, 30-pound silver cup designed by Tiffany and Company. Embossed on the precious metal was the image of Vanderbilt in his proudest racing moment, atop his Mercedes at the 1904 Ormond-Daytona Automobile Tournament. (Courtesy of the Suffolk County Vanderbilt Museum.)

Nailed to trees and telegraph poles or pasted to barns in the summer of 1904, posters from organizers of the Vanderbilt Cup Race announced the first international automobile competition to be held in the United States. In addition to promoting the Saturday, October 8, 1904, race date and the early 6:00 a.m. start around the 30-mile course, the poster enumerated rules of conduct for crossing the public roads and monitoring the whereabouts of animals with a warning "chain your dogs and lock up your fowls!" The poster drew the ire of many Nassau County farmers who used the roads to bring their goods to New York City.

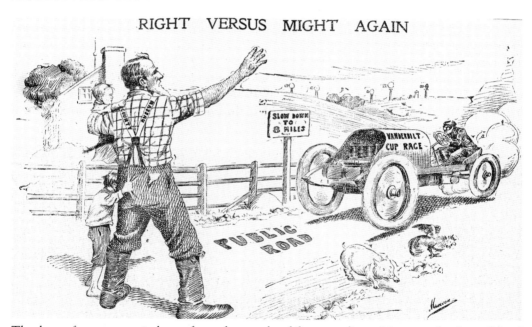

The lure of an economic boon from thousands of free-spending visitors to the Long Island community proved incentive enough for Nassau County supervisors to approve the use of public roads for automobile racing when they met on August 23, 1904. Unconvinced, however, were many farmers who still relied on horses for transportation and saw automobiles as playthings of the idle rich. Despite several legal attempts to stop the race, Nassau County supervisors and judges gave their approval a few days before the Saturday race date. (Courtesy of the Suffolk County Vanderbilt Museum.)

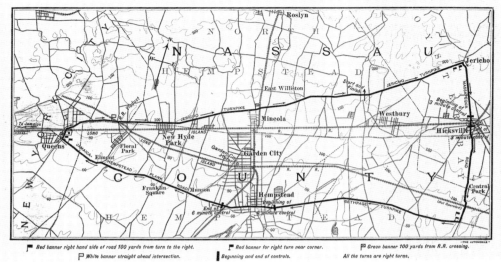

SCALE MAP OF THE WILLIAM K. VANDERBILT, JR., CUP RACE COURSE IN NEW YORK CITY AND NASSAU COUNTY, LONG ISLAND.

The race course traversed 30.24 miles of public roads in the center of Long Island. Triangular in shape, Jericho Turnpike, Massapequa-Hicksville Road, and the new Hempstead-Bethpage Turnpike formed its sides. Running clockwise and beginning in Westbury, the three long stretches of roads were connected by major turns in Jericho, Plainedge, and Queens. The plan called for a 10-lap race with drivers stopping in two controls on each tour of the course. The controls were in the towns of Hicksville and Hempstead, the largest population centers in Nassau County. At the controls, the cars were stopped, inspected, and allowed to proceed slowly over railroad tracks led by officials on bicycles. Deducting the length of the two controls, one lap of the course was 28.44 miles, making the race 284.4 miles.

In the center of the course was the Garden City Hotel, the largest and grandest hotel on Long Island and headquarters for the AAA Race Commission. Days before the race, the hotel was booked to its capacity. (Courtesy of the Suffolk County Historical Society.)

The race's daybreak start attracted thousands of adventurous souls who streamed into Long Island from New York City continuously on Friday night and early Saturday. With hotels and roadhouses overflowing, they camped, gambled, drank, socialized, and established a tradition of revelry that became a hallmark of the event. (Courtesy of the National Automotive History Collection at the Detroit Public Library.)

In the custom of the day, the crowds typically wore their finest clothes to great public events such as the Vanderbilt Cup Race. Fashion called for virtually all men to wear hats. The dome-shaped bowler with narrow brim was particularly popular. (Courtesy of the National Automotive History Collection at the Detroit Public Library.)

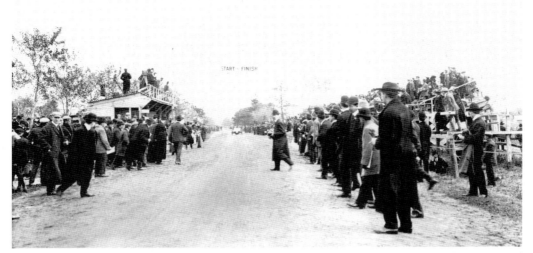

High society also embraced the brainchild of one of their own—William K. Vanderbilt Jr. Joined by the leaders of the automotive industry, they gathered in a cluster of over 2,500 people in and around the rough-hewn wood-plank grandstand at the Westbury start-finish line on Jericho Turnpike. An estimated 25,000 to 50,000 spectators lined the entire course so dangerously close that they were very much a part of the spectacle. (Courtesy of the Suffolk County Historical Society.)

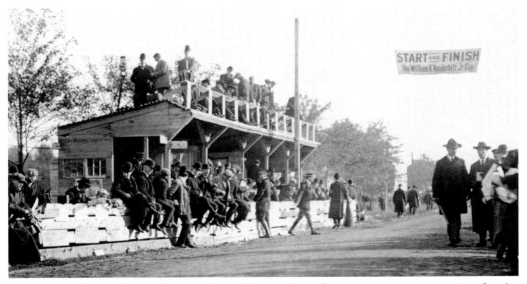

The press and officials stand across from the grandstand was a great vantage point for the cameraman from American Mutoscope and Biograph. The camera was located on the top level of the stand. This company produced a two-minute film of the race, one of the earliest sports films ever made. William K. Vanderbilt Jr. can be seen walking away from the stand while acting as the race referee. (Courtesy of the National Automotive History Collection at the Detroit Public Library.)

Before the 6:00 a.m. start, touring cars drove the course to park behind the grandstand that slowly filled up with spectators. These were people of prominence, members of wealthy families, government leaders, and business executives. The gathering, which included such stellar names as John Jacob Astor, was compared to the attendees of a Metropolitan Opera opening night. (Courtesy of the Helck family collection.)

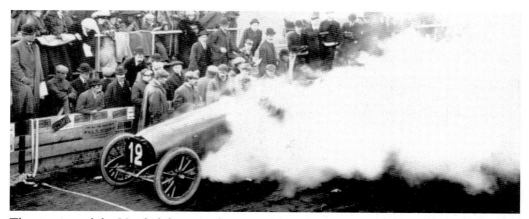

The prestige of the Vanderbilt name drew many leading European manufacturers and drivers to the race. Cars entered by France (6), the United States (5), Germany (5), and Italy (2) were among the 18 starters. The French cars included three 90-horsepower Panhards, a 60-horsepower Renault, an 80-horsepower De Dietrich, and the 80-horsepower No. 12 Clement-Bayard (pictured above at the starting line). At the wheel of the De Dietrich was one of the leading European drivers, Fernand Gabriel, who finished second in the 1903 Gordon Bennett Race and was the declared winner of the 1903 Paris-Madrid Race. The German cars were all Mercedes, each owned by Americans. Two 90-horsepower Fiats (Fabbrica Italiana Automobili Torino) represented Italy, one owned by William K. Vanderbilt Jr.'s cousin Alfred Gwynne Vanderbilt. (Courtesy of the Helck family collection.)

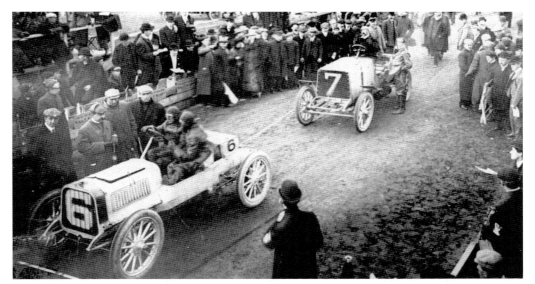

Each race car carried two men, the driver and a mechanic called a riding mechanician. The mechanician assisted with repairs, helped navigate the course, and worked a hand pump to maintain oil pressure. Outclassed by the Europeans' powerful racers, some with large 90-horsepower engines, the five American starters included modified touring cars such as the 24-horsepower No. 6 Pope-Toledo driven by Herb Lytle. (Courtesy of the Helck family collection.)

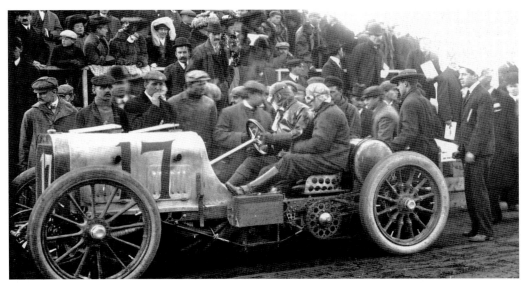

Only the American 75-horsepower No. 17 Simplex driven and owned by Frank Croker, son of the Tammany Hall boss Richard Croker, approached the power of the European machines. During the prerace weigh-in, the Simplex failed to meet the race weight limitation of 2,204 pounds. Croker reduced the weight by drilling holes throughout the chassis, which can be seen below the engine's hood and on the mechanician's seat. (Courtesy of the National Automotive History Collection at the Detroit Public Library.)

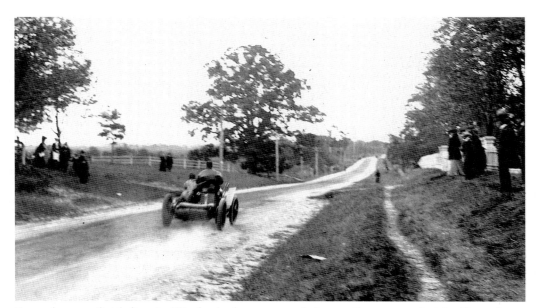

From the start-finish line in Westbury, the cars raced three miles east on Jericho Turnpike to the hamlet of Jericho. The first car on the road was the German 60-horsepower No. 1 Mercedes driven by Albert Campbell. The car was running in the fifth position when the race was called, over 60 miles behind the leaders. (Courtesy of the Suffolk County Historical Society.)

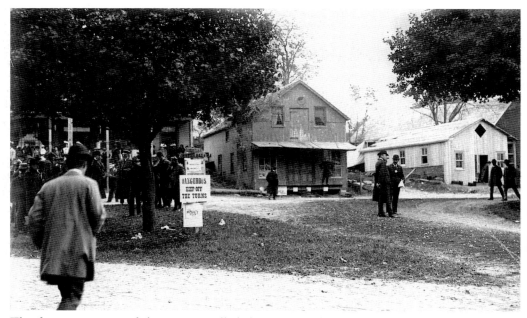

The first major turn of the course, called the "Curve of Death" by newspapers, was located on narrow streets surrounded by the Jericho General Store and W. B. Powell's Jericho Hotel. Flagmen were hired by the AAA Race Commission to keep the turn clear and warn spectators of approaching cars. (Courtesy of the Suffolk County Historical Society.)

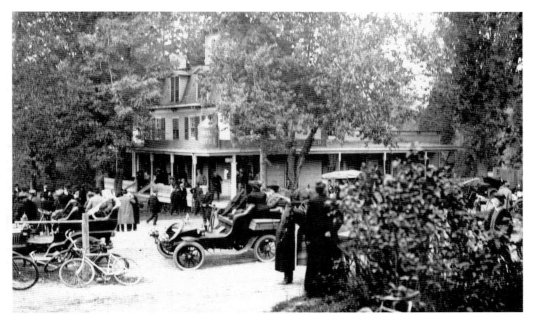

W. B. Powell's Jericho Hotel was a popular location from which to view the action at the Jericho turn. The two-story building provided great sight lines and also housed Fernand Gabriel's De Dietrich team. (Courtesy of the Suffolk County Historical Society.)

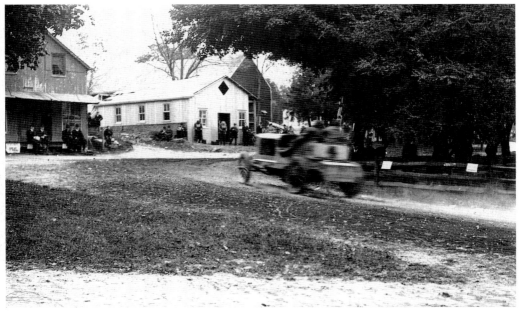

A photographer on the porch of the Jericho Hotel captured the American 60-horsepower No. 4 Pope-Toledo taking the Jericho turn. The car, driven by A. C. Webb, broke a steering knuckle during lap 6 and finished a disappointing 10th. (Courtesy of the Suffolk County Historical Society.)

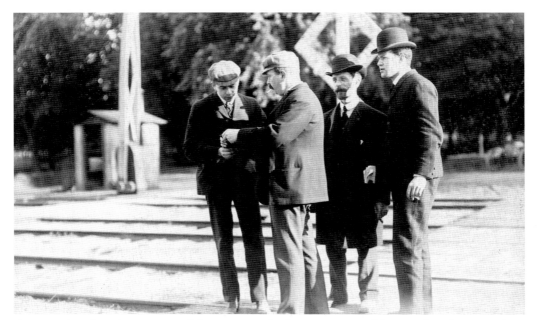

Active railroad tracks intersected the circuit at five locations, two of them within the controls in Hicksville and Hempstead. As arranged with the Long Island Rail Road, race deputies stopped trains when they approached the course crossings. (Courtesy of the National Automotive History Collection at the Detroit Public Library.)

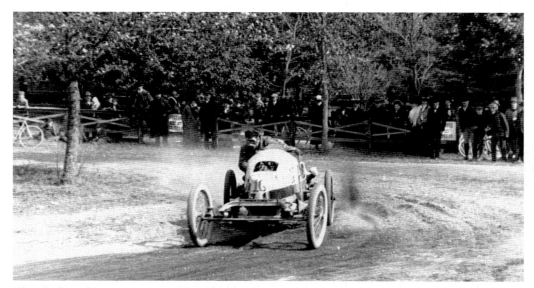

The sleek 30-horsepower No. 16 Packard *Gray Wolf* was a dirt-track car designed by its driver Charles Schmidt. The first Packard racer had previously set one-mile and five-mile records in January 1904. An American Mutoscope and Biograph cameraman captured the *Gray Wolf* taking the second major turn on the course from Massapequa-Hicksville Road to the Hempstead-Bethpage Turnpike. (Courtesy of the Helck family collection.)

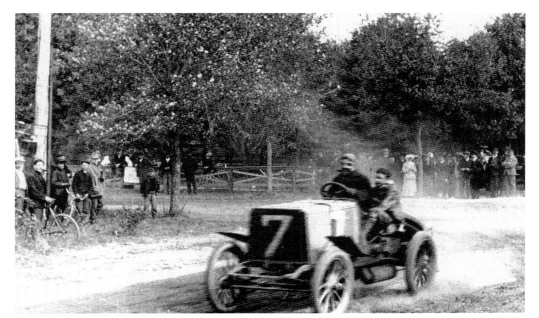

During lap 3, George Heath's No. 7 Panhard was in second place when he took the Massapequa turn. Before the race, Heath's Panhard was one of the favorites to win. (Courtesy of the Helck family collection.)

The two miles of the Hempstead-Bethpage Turnpike were rebuilt for the 1904 race. Over 100 workers spread stone and crushed it with rollers one week before the race. Fernand Gabriel's No. 2 De Dietrich is seen flying at over 62 miles per hour on the new road, now known as Hempstead Turnpike. (Courtesy of the Suffolk County Historical Society.)

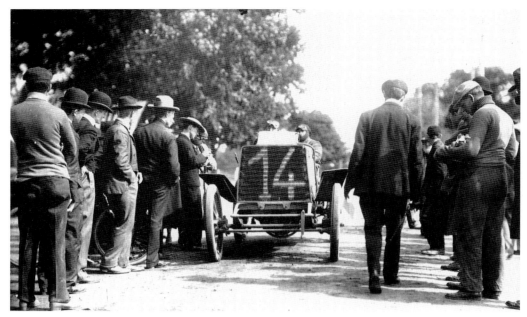

Through the first three laps, the 90-horsepower No. 14 Panhard driven by George Teste led the race, averaging 66.4 miles per hour. Teste's car was stopped at the Hempstead control for inspection on Fulton Street. During lap 4, when Teste's car left the race with ignition problems, George Heath's Panhard took the lead for the first time. (Courtesy of the National Automotive History Collection at the Detroit Public Library.)

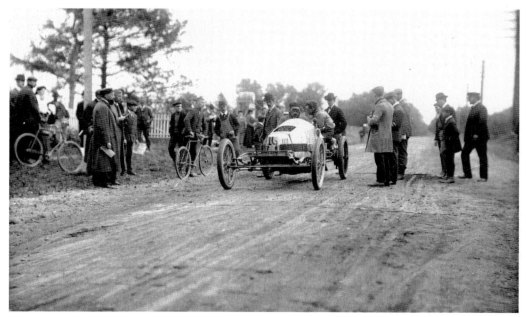

Shown stopped at the Hempstead control, the small Packard *Gray Wolf* proved surprisingly durable and was in fourth position when the race ended. (Courtesy of the George Eastman House.)

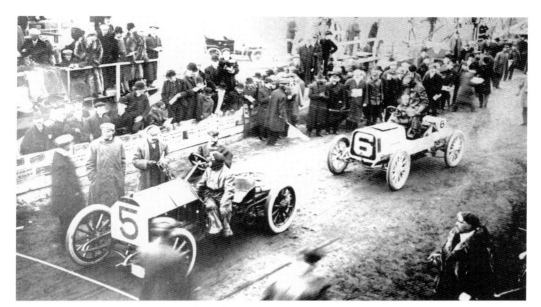

The first American international road race was exciting and dangerous. The No. 5 Mercedes driven by George Arents Jr., an heir to a tobacco fortune, was involved in the race's most serious accident. Riding with Arents, who was participating in his first race, was his mechanician Carl Mensel. (Courtesy of the Helck family collection.)

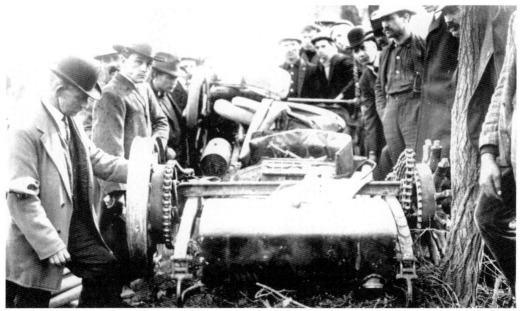

When approaching Elmont on the Hempstead-Jamaica Road, Arents's left rear tire blew. The bare rim struck a trolley track, overturning the car. Arents was thrown from the car, suffering a serious head injury from which he eventually fully recovered. Tragically, Mensel was pinned under the car and fatally injured. (Courtesy of the Helck family collection.)

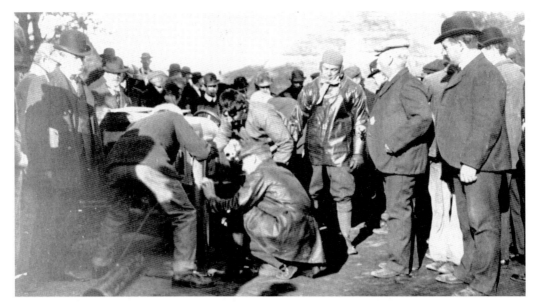

The wear and tear of the rough roads on the course was no more apparent than with Frank Croker's Simplex. The car, drilled throughout its chassis to meet the maximum weight limitation, literally sagged and bowed under the strain of its own weight. This bending affected alignment of the drive train and transmission and forced a half-hour delay during the fourth lap for makeshift repairs at its repair station. (Courtesy of the Helck family collection.)

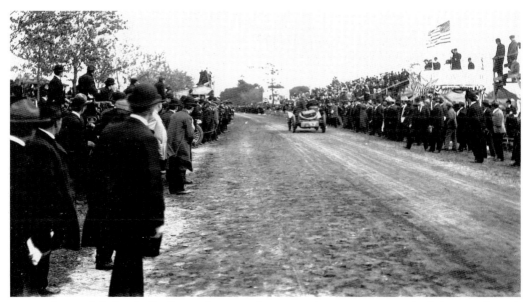

Driver Fernand Gabriel's De Dietrich snapped a pump chain as it approached the grandstand. When riding mechanician Dominque Miollans (left) opened the toolbox in the rear of the car, he discovered that all the tools had fallen out. The chain was spliced with a bent wire. (Courtesy of the Suffolk County Historical Society.)

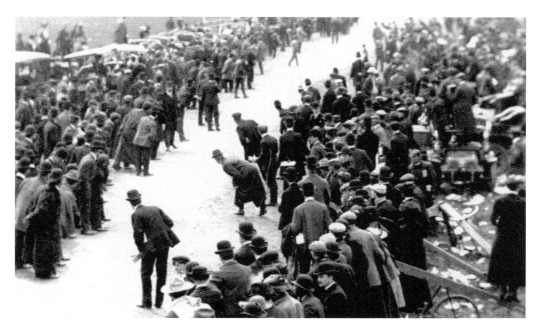

After five laps, only 9 of the 18 starters were still running. Restless spectators ventured dangerously out onto Jericho Turnpike near the Westbury grandstand, searching for the few remaining approaching cars. (Courtesy of the Helck family collection.)

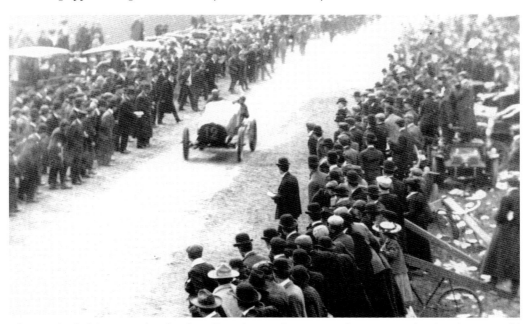

The race boiled down to a battle of two French cars, George Heath's No. 7 Panhard and 21-year-old Albert Clement Jr.'s No. 12 Clement-Bayard. Tire failure struck the Panhard in Queens, allowing Clement to seize the lead in the eighth and ninth laps, only to see George Heath stage a stirring comeback in a brilliant last-lap drive. (Courtesy of the Helck family collection.)

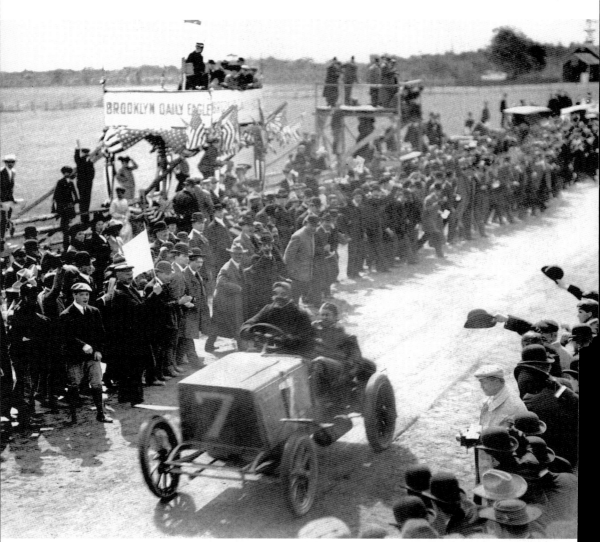

One of the most noteworthy photographers of the early 20th century, Russian immigrant Nathan Lazarnick captured the winning moment of the race. After 6 hours, 56 minutes, and 45 seconds, George Heath's Panhard was the first car over the finish line, averaging 52.2 miles per hour. Only 1 minute and 26 seconds behind in total time, the Clement-Bayard finished in second place. With the two leaders having completed the race, the crowds near the grandstand swarmed onto the course. Fearful for the lives of the spectators and drivers, the race was stopped. When the race was called, the American Pope-Toledo driven by Herb Lytle was in third place. (Courtesy of the National Automotive History Collection at the Detroit Public Library.)

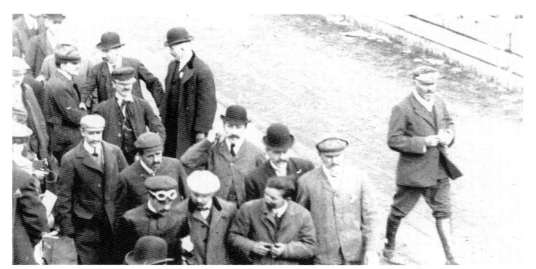

An anguished Albert Clement Jr., his face coated with oil and dust, approached race referee William K. Vanderbilt Jr. immediately after the race. Clement protested that he was unfairly delayed at the Hicksville and Hempstead controls. In a late-night meeting at their Garden City Hotel headquarters, the Vanderbilt Race Commission, led by Vanderbilt, denied the protest and declared Heath's Panhard the winner. The Vanderbilt Cup was awarded to France. (Courtesy of the Helck family collection.)

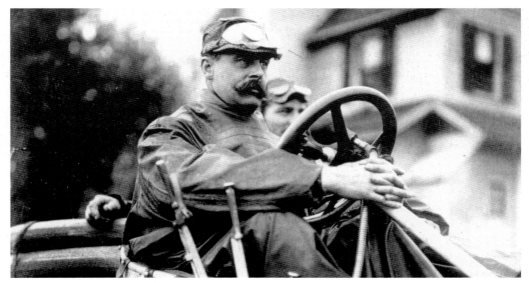

Born in America and a British citizen living in Paris, George Heath had the greatest year of his racing career in 1904. The Panhard employee not only won the Vanderbilt Cup but also claimed victory in the 1904 Circuit des Ardennes in Belgium in July. After winning the first Vanderbilt Cup Race, Heath said, "My control of my machine is instinctive. I know at all times just what speed I am making. Constant practice enables me to do these things. I like to travel fast, and I like to handle my car at great speed." (Courtesy of the Henry Ford.)

The race made front-page headlines throughout the world and received overall favorable reactions. Although France had won the race, the winning driver was born in America and the American Pope-Toledo and Packard cars had performed better than expected. William K. Vanderbilt Jr., interviewed in the *New York Journal-American*, stated, "I consider the event a very successful one in every way. The race proved that the automobile is a wonderful piece of mechanism, capable of carrying people safely over long distances." The trade magazine *Motor Age* reported, "Nassau County never saw such a day and will not again—until next year. It marked the beginning of American road racing and not the end."

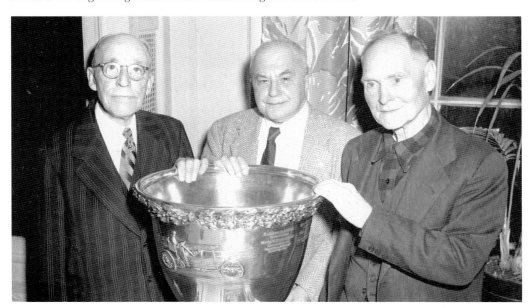

The 50th anniversary of the 1904 Vanderbilt Cup Race was celebrated in 1954 at an appropriate location—the Garden City Hotel. Holding the Vanderbilt Cup are three participants in the race, from left to right, George Arents, driver of the crashed No. 5 Mercedes; Alfred Poole, mechanician for the No. 3 Royal Tourist; and Joe Tracy, driver of the No. 3 Royal Tourist. (Courtesy of the Helck family collection.)

3

The 1905 Vanderbilt Cup Race

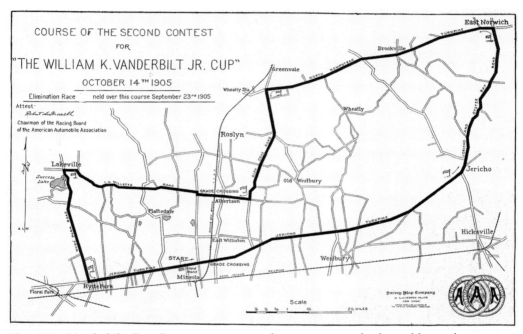

The 1904 Vanderbilt Cup Race was an immediate success with the public and supporters of automobile racing. America finally had a major road race that attracted great drivers and cars from around the world. Newspapers and automobile trade journals heaped praise on William K. Vanderbilt Jr. and his event. Enthusiasm swelled in the public and the automobile factories, ensuring a second Vanderbilt Cup Race in 1905 to be held on October 14. It was obvious to American and European automobile manufacturers that exciting road races attracted more customers to their products than the less dramatic reliability trials also run during the period. Many drivers, including 1904 winner George Heath, were critical of the Hempstead and Hicksville controls, which required the cars to stop for periods of two and six minutes. In response, the AAA Race Commission modified the 1905 course to eliminate the stops in large towns and reduce the number of sharp turns. The new layout was 28.3 miles long, still through rural Long Island. At 10 laps, the distance covered in the race would be nearly the same as in 1904 at 283 miles. The start-finish line and grandstand were moved to Jericho Turnpike in Mineola, approximately four miles west of the 1904 location.

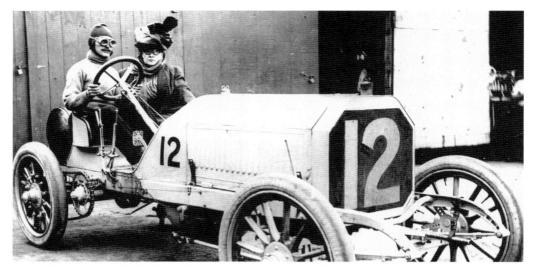

Vanderbilt Cup Race rules limited every country's team to five cars. With 12 entries from America in 1905, an additional qualification race called the American Elimination Trial was staged three weeks before the Vanderbilt Cup Race. A four-lap race totaling 113.2 miles was held over the new course. Prior to the trial, driver Joe Tracy gave Hearst journalist Ada Patterson a ride in the 90-horsepower Locomobile entry. Patterson was one of the original sob sister reporters known for investigative exposés that led to reform of public institutions.

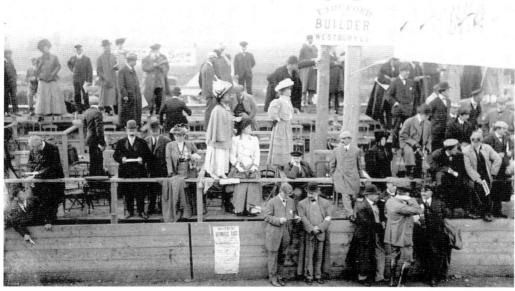

Virginia Graham "Birdie" Vanderbilt, William K. Vanderbilt Jr.'s wife, was the major celebrity at the American Elimination Trial. Near the end of the race, she (left) stood on the railing to view the racers. She was accompanied by her friends Natalie Martin (center) and Caroline Stevenson (right). (Courtesy of Brown Brothers.)

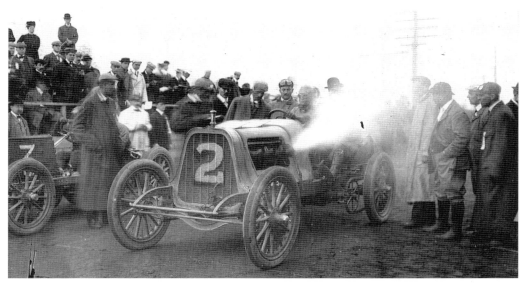

The winner of the American Elimination Trial was Bert Dingley in the 60-horsepower No. 2 Pope-Toledo. Dingley overtook Joe Tracy's Locomobile on the last lap, averaging 56.5 miles per hour and winning by 59 seconds. Despite an outcry from newspapers, automobile magazines, and manufacturers, the AAA Race Commission retained only the top two finishers and selected three also-rans to complete the team: a front-wheel drive Christie, a White Steamer, and another Pope-Toledo.

Among the companies unhappy with the commission's decision was the Premier Motor Manufacturing Company, whose car was ruled overweight and ineligible for the trial race. Premier placed advertisements in the automobile trade journals protesting the decision. The car was to be driven by Indiana daredevil Carl Fisher (shown in the advertisement), the future developer of Miami Beach, Montauk, and the Indianapolis Motor Speedway.

VANDERBILT CUP RACES OF LONG ISLAND

Competing against the five American cars, France, Germany, and Italy started 14 of their greatest cars and drivers. Fiat provided five cars for Italy, with engines ranging from 90 to 120 horsepower. The most prominent driver in the race was Italian Vincenzo Lancia, who won the 1904 Florio Cup, covering the 231-mile Italian course with a then-astounding average speed of 71.88 miles per hour. The affable Lancia was both the crowd and gamblers' favorite and later went on to develop his own car company. (Courtesy of the Henry Ford.)

Another Fiat was driven by a novice Swiss-born driver whose name would eventually become one of the most famous brands in American car history—Louis Chevrolet. Known for his daring and sometimes reckless racing style, Chevrolet completely destroyed his 110-horsepower Fiat the Monday before the race in a practice run. Uninjured, Chevrolet used a backup 90-horsepower car for the race. (Courtesy of the Helck family collection.)

A 40-horsepower White Steamer made by the White Sewing Machine Company was one of the five American entries. Seen with its driver Walter White practicing in front of financier Clarence Mackey's 648-acre Harbor Hill estate in Roslyn, the steamer was the only steam-powered car ever to compete for the Vanderbilt Cup. (Courtesy of the Suffolk County Vanderbilt Museum.)

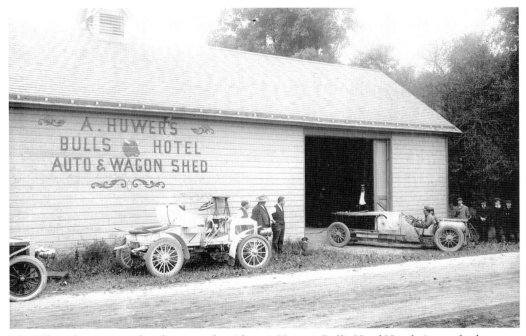

The White Steamer was headquartered at Aloyous Huwer's Bull's Head Hotel. A popular location for viewing the race, the hotel and garage barn were located at the junction of North Hempstead Turnpike and Glen Cove Road in Greenvale. (Courtesy of the George Eastman House.)

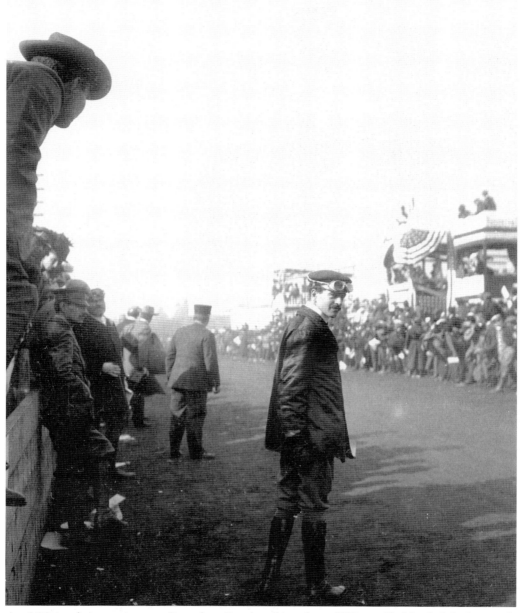
At 6:00 in the morning on Saturday, October 14, referee William K. Vanderbilt Jr. stands ready to officiate at the Mineola grandstand. (Courtesy of the Keystone-Mast Collection, UCR/California Museum of Photography, University of California, Riverside.)

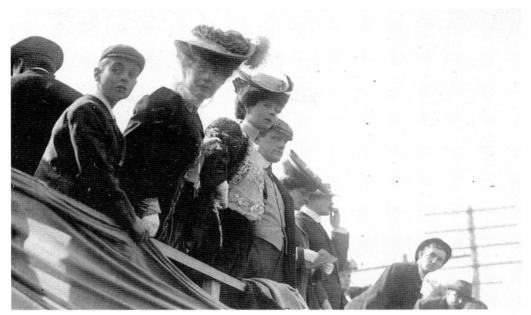

Approximately 5,000 people gathered at the Mineola grandstand, including William K. Vanderbilt Jr.'s sister Consuelo, the Duchess of Marlborough (center wearing a white blouse). Encouraged by her mother, Alva Vanderbilt, Consuelo married England's Duke of Marlborough in 1895. (Courtesy of the Suffolk County Vanderbilt Museum.)

William K. Vanderbilt Jr.'s wife Virginia (right) also attended the race, accompanied by her friend Natalie Martin (left). Virginia attended the 1904, 1905, 1906, and 1908 Vanderbilt Cup Races. Even after her separation from William in 1909, she attended the 1915 Vanderbilt Cup Race in San Francisco. (Courtesy of the Keystone-Mast Collection, UCR/ California Museum of Photography, University of California, Riverside.)

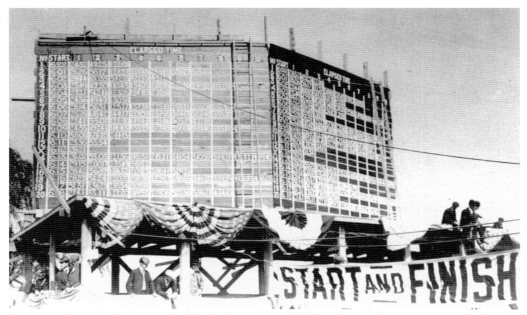

Opposite the grandstand, a double-decker press and officials stand was constructed. On top of this stand was a large two-sided scoreboard to help spectators keep track of the drivers' lap-by-lap positions. (Courtesy of the National Automotive History Collection at the Detroit Public Library.)

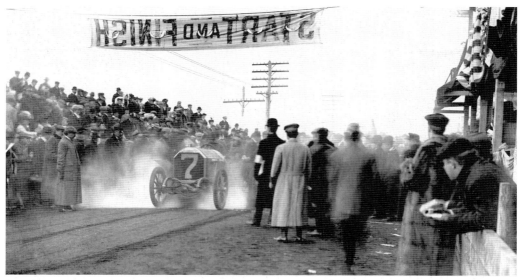

Popular American driver Joe Tracy and his riding mechanician Al Poole received a resounding ovation when they approached the line in the 90-horsepower No. 7 Locomobile. The second-place finisher in the American Elimination Trial, the red Locomobile was as powerful as any American entry and, at 1,195 cubic inches, had the biggest engine in the race. (Courtesy of the National Automotive History Collection at the Detroit Public Library.)

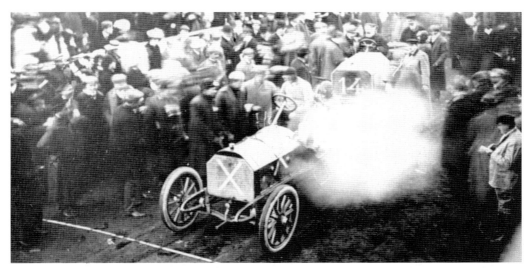

Country representation in the Vanderbilt Cup Races was determined by the manufacturer of the car, not the nationality of its driver or owner. Four Mercedes owned by Americans were entered on behalf of Germany. The drivers representing Germany included Belgian driver Camille Jenatzy, the first man to hit 60 miles per hour and the winner of the 1903 Gordon Bennett Race, and American Al Campbell, who placed a large X on the front of his car instead of the bad luck hoodoo number 13. (Courtesy of the Helck family collection.)

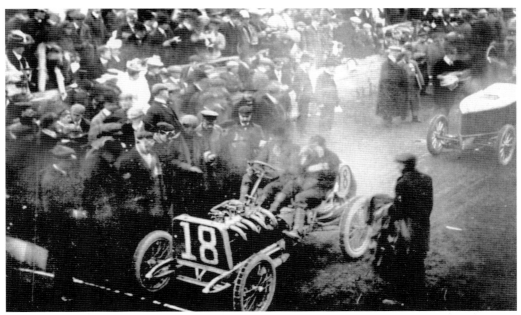

Darracq and Company of France was represented by two 80-horsepower cars in the race, the No. 18 car driven by Victor Hemery and the No. 6 car driven by Louis Wagner. The well-engineered Darracqs were the lightest cars in the race and used shaft drives instead of chains. (Courtesy of the Helck family collection.)

VANDERBILT CUP RACES OF LONG ISLAND

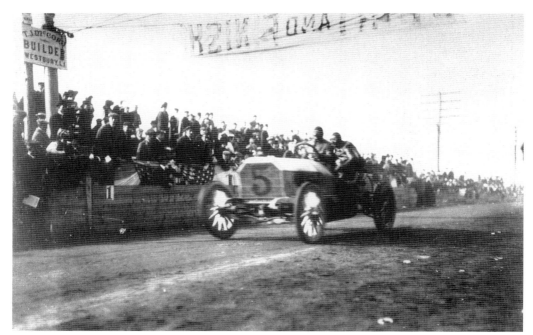

Driving the No. 5 Mercedes, "society swell" Foxhall Keene was an active American sportsman proficient at polo, equestrian events, and pigeon shooting. A friend of Vanderbilt's, Keene lived just five miles east of the starting line in his Westbury estate Rosemary Hall. The grandstand crowd saluted the native Long Islander after his strong start. (Courtesy of the Helck family collection.)

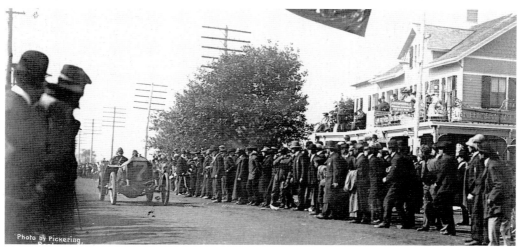

Joe Tracy is driving a steady race in his No. 7 Locomobile as it passes Krug's Hotel on Jericho Turnpike in Mineola. Krug's Hotel was a favorite spot for teams and enthusiasts alike. During the years the course ran directly past the hotel, spectators stationed there were nicknamed "Krug's Klockers" because of their enthusiasm for timing practice runs.

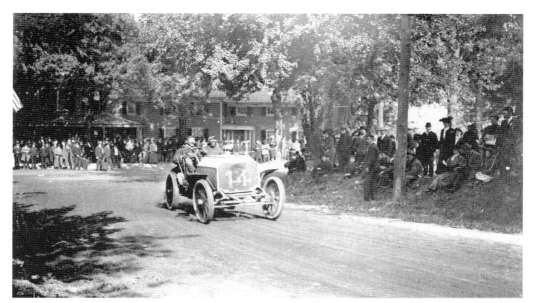

George Heath, winner of the 1904 Vanderbilt Cup Race, made another strong showing in his new and larger blue-gray 120-horsepower No. 14 Panhard. As he made the Lakeville turn from I. U. Willets Road during lap 4, he was in a solid second place behind Vincenzo Lancia. (Courtesy of the Suffolk County Vanderbilt Museum.)

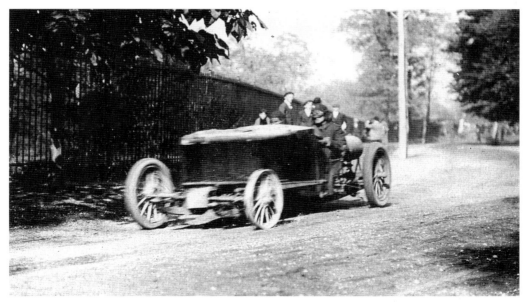

The unique 40-horsepower No. 19 White Steamer sputtered early in the race. During lap 5, the steamer punctured its left front tire at the Guinea Woods turn and limped on its rim as it passed William K. Vanderbilt Jr.'s Deepdale estate in Lake Success. Portions of the gates surrounding the Deepdale estate (left) are still standing today on Lakeville Avenue. (Courtesy of the Suffolk County Vanderbilt Museum.)

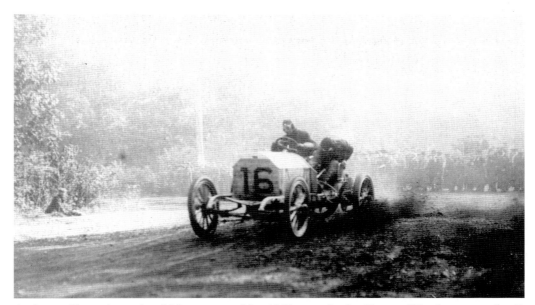

As Louis Chevrolet in his 90-horsepower No. 16 Fiat made the Guinea Woods turn on lap 7, he stood in 10th place. His car was soon out of the race as he ran into a telegraph pole at the S curve at Willis Avenue and I. U. Willets Road in Albertson. (Courtesy of the Helck family collection.)

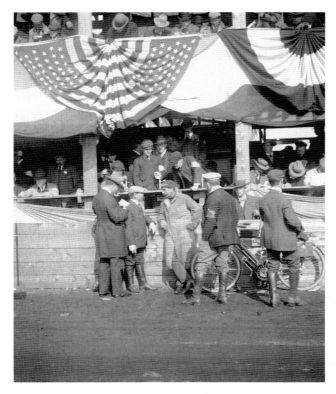

While making a move to third place during lap 6, Foxhall Keene crashed his Mercedes and broke a wheel at the S curve on Willis Avenue in Albertson. After the crash, Keene (center) walked one mile south to the Mineola grandstand and discussed the accident with Robert Lee Morrell (second from left, wearing a cap), chairman of the AAA Race Commission. (Courtesy of the Keystone-Mast Collection, UCR/California Museum of Photography, University of California, Riverside.)

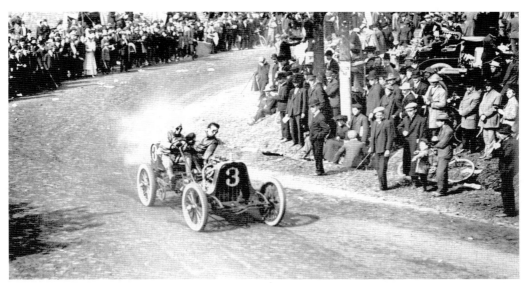

The final major turn on the course was in New Hyde Park at the intersection of Lakeville Road and Jericho Turnpike. The steeple of the church on the southeast corner was a natural location for race photographers. When the American Elimination Trial champion Bert Dingley made the turn in the No. 3 Pope-Toledo during lap 5, he was a disappointing 12th place. (Courtesy of the Suffolk County Vanderbilt Museum.)

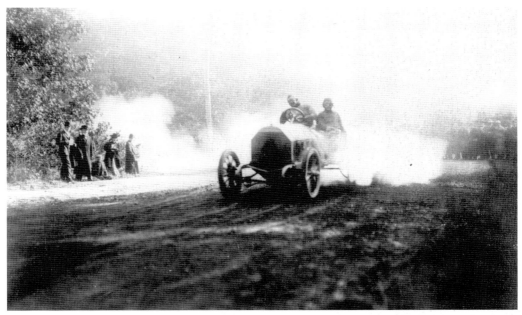

Vincenzo Lancia dominated the race from the beginning in his 120-horsepower No. 4 Fiat, cutting laps at a breathtaking pace to average an astonishing 72 miles per hour over the first 113 miles. As he made the Guinea Woods turn in Old Westbury on lap 7, Lancia had a commanding lead of over 30 miles. (Courtesy of the Helck family collection.)

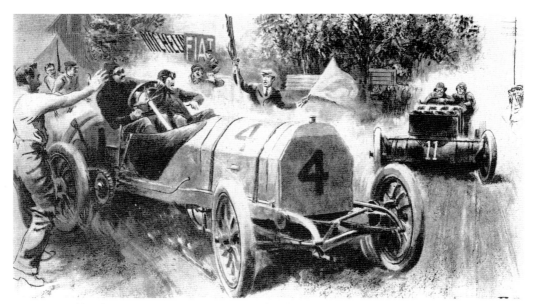

As captured by the prominent painter Peter Helck (1893–1988), Vincenzo Lancia was impatient to get back on course after replacing a tire on lap 8 when leading by over 30 miles. He misjudged the speed of the approaching racer Walter Christie. He pulled onto the road in front of the American car, which hit him from behind. Lancia's two rear wheels took over 40 minutes to repair. (Courtesy of the Helck family collection.)

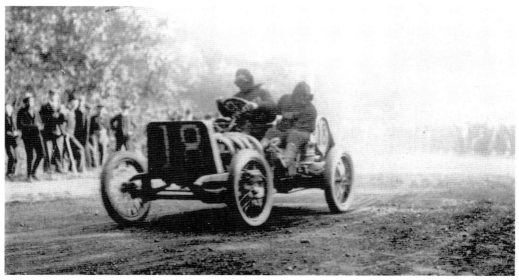

With Lancia delayed 40 minutes for repairs, the race came down to a battle between two French cars, Victor Hemery's No. 18 Darracq and George Heath's No. 14 Panhard. As Hemery made the Guinea Woods turn during lap 9, he led Heath by three minutes. During the last lap, Heath reduced the lead by almost a minute but could not catch Hemery. (Courtesy of the Helck family collection.)

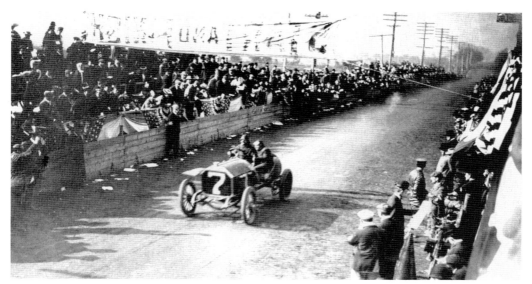

Even though his car had suffered significant damage from the crash with Christie, Lancia again scorched the course on lap 9 at 71 miles per hour, climbing back from sixth place to third. The grandstand buzzed about America's chances as Joe Tracy picked up speed and was in fourth position as he began the final lap in his No. 7 Locomobile. (Courtesy of the Helck family collection.)

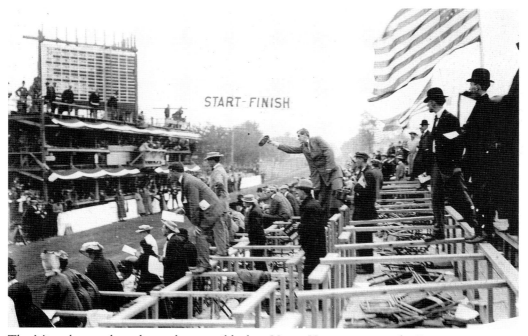

The Mineola grandstand crowd went wild when Victor Hemery won in the Darracq, averaging 61.5 miles per hour. The 1904 winner, George Heath, finished in second place only 3 minutes and 42 seconds behind. (Courtesy of the Helck family collection.)

With the first two places decided, the battle for third place was heated between Vincenzo Lancia's Fiat and Joe Tracy's Locomobile. After Victor Hemery completed his winning run, spectators packed the road near the grandstand. Lancia was forced to bring the Fiat to a crawl before he crossed the finish line. He was stormed by a horde of admirers for his amazing race in what the *New York Times* called a "hurricane of cheers." (Courtesy of the Henry Ford.)

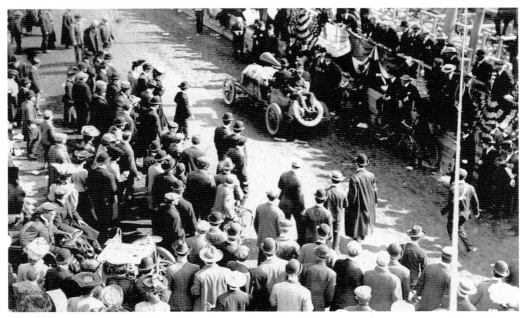

With Tracy's Locomobile due within minutes and third place at stake, announcer Peter Prunty climbed into Lancia's car and was able to partially clear the course. Since the No. 7 Locomobile had started the race three minutes after the No. 4 Fiat, Tracy needed to finish within three minutes to take third place from Lancia. (Courtesy of the Suffolk County Vanderbilt Museum.)

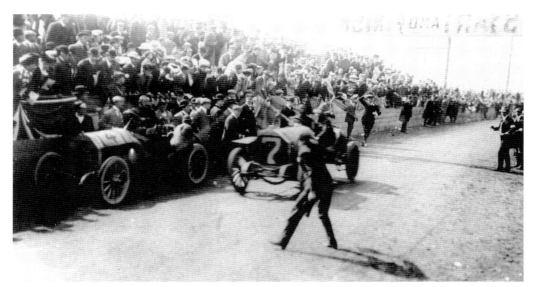

Within a minute of Lancia's finish, Tracy's Locomobile (right) crossed the finish line while the disappointed Lancia watched in his car. Tracy had done the seemingly impossible by making up time on the flying Italian and beating Lancia by two minutes and five seconds, averaging 56.9 miles per hour. The third-place finish was the first time an American car had ever placed in an international competition. (Courtesy of the Helck family collection.)

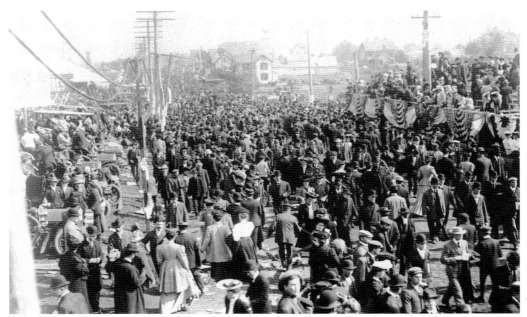

After the first four cars finished, crowds once again swarmed onto Jericho Turnpike around the grandstand. Referee William K. Vanderbilt Jr. stopped the race with four cars still running on the course. Over 100,000 people lined the course's perimeter, resulting in one of the largest crowds ever to see a sporting event in this country up to that time. (Courtesy of the Henry Ford.)

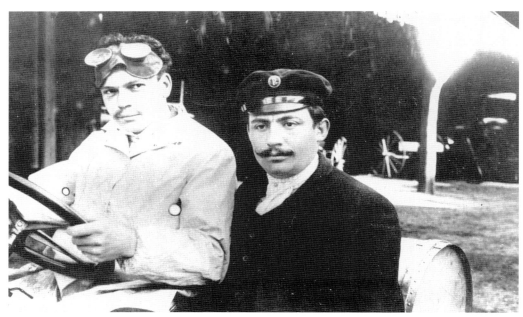

Known as a ruthless competitor, winner Victor Hemery was one of the most highly regarded drivers in the field. Only weeks before the Vanderbilt Cup Race, he won the prestigious Belgian International Races at the Circuit des Ardennes. In 1904, he won acclaim for his victories in the Mount Ventoux and Gaillon hill climbs. (Courtesy of the Helck family collection.)

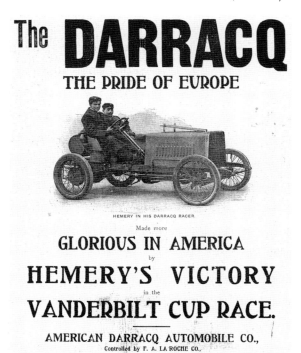

Darracq celebrated its victory with advertisements in American automobile trade journals proclaiming its car as the "Pride of Europe." In hopes of selling its product to prospective American customers, the advertisements were placed by the New York distributor of the Darracq.

4

THE 1906 VANDERBILT CUP RACE

No greater evidence of the success of the Vanderbilt Cup Race emerged than when popular culture embraced it. In January 1906, the two races inspired a Broadway musical titled, aptly enough, *The Vanderbilt Cup*, starring 17-year-old sensation Elsie Janis. Before the 1906 competition, race participants had box seats to watch Janis perform on stage: (from left to right) George Robertson, Ralph Mongini, Al Poole, Walter Christie, Louis Wagner, unidentified, Louis Vivet, and Joe Tracy. The show featured appearances by track racer Barney Oldfield, who developed special effects to simulate the race onstage using a treadmill.

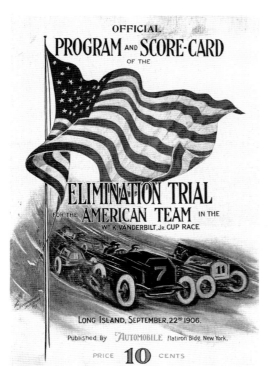

As in 1905, an American Elimination Trial determined the five racers to represent the United States in the Vanderbilt Cup Race. In response to criticism that anything less than a full 10-lap race was an adequate test, the trial covered the full 297 miles. Of 15 entries, 12 cars survived the practice runs to race on Saturday, September 22, 1906.

Veteran Vanderbilt Cup Race driver Joe Tracy (right) and his riding mechanician Al Poole gave their new 90-horsepower Locomobile a practice run around their Lakeville Hotel headquarters near Lake Success. Tracy won the American Elimination Trial after battling for much of the distance with Hubert LeBlon's Thomas entry. Tracy averaged 52.3 miles per hour for the 297-mile race. (Courtesy of the Helck family collection.)

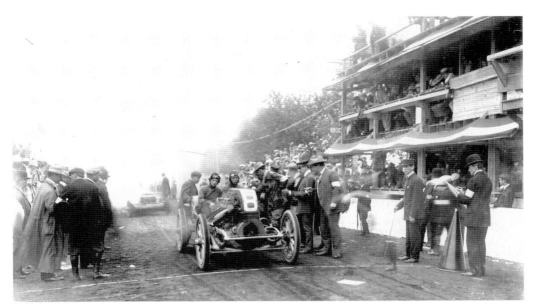

Another innovative machine showcased in the 1906 American Elimination Trial was the unique, air-cooled Frayer-Miller entry with designer Lee Frayer (right) at the wheel. The only car to place the driver on the left side, this car broke a radius rod on the first lap and finished last. An identical Frayer-Miller car successfully qualified for the big race. (Courtesy of the National Automotive History Collection at the Detroit Public Library.)

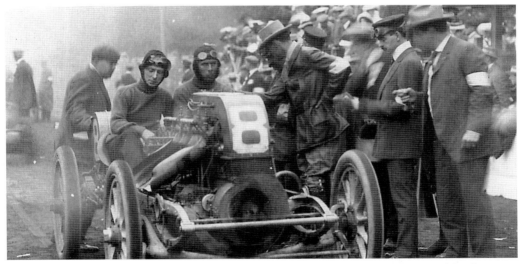

Frayer's riding mechanician, 16-year-old Eddie Rickenbacker (left), was arguably the most significant historical figure present that day. Rickenbacker later drove in both the 1915 Vanderbilt Cup Race and the Indianapolis 500. He even purchased the Indianapolis Motor Speedway in 1927. His greatest moments came from his career in aviation, where he became America's World War I flying ace and, later in life, rose to president and general manager of Eastern Airlines. (Courtesy of the National Automotive History Collection at the Detroit Public Library.)

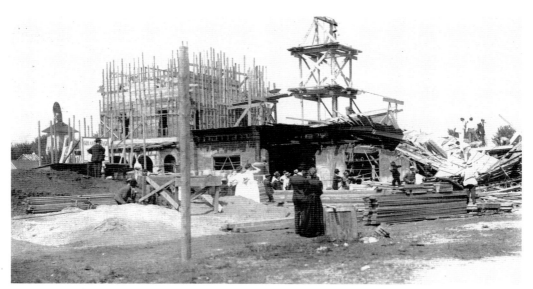

A four-story garage, under construction for the Mercedes teams, collapsed two days prior to the beginning of practice for the American Elimination Trial. The garage was being built for Robert Graves, owner of the No. 3 Mercedes to be driven by Camille Jenatzy. Three men were killed and a dozen more injured, all employees of the George A. Avery construction company. (Courtesy of the Henry Ford.)

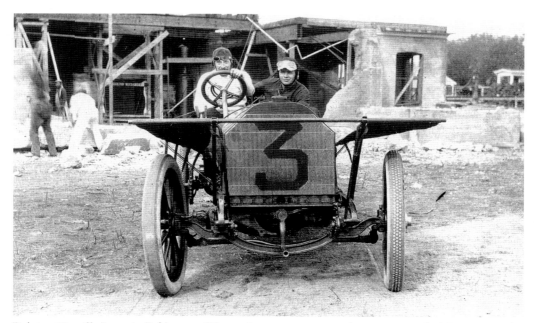

Belgian Camille Jenatzy (left), one of Europe's most prominent drivers, sits in the No. 3 Mercedes in front of the collapsed Graves Garage. Jenatzy drove a spirited race but was slowed by tire failures and finished fifth. The short-tempered 35-year-old reportedly swatted the heads of people crowding the road after the race.

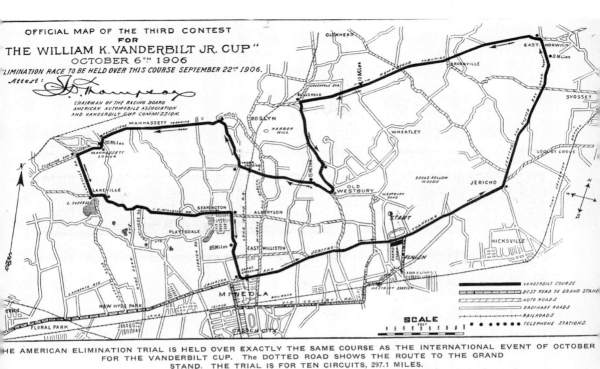

THE AMERICAN ELIMINATION TRIAL IS HELD OVER EXACTLY THE SAME COURSE AS THE INTERNATIONAL EVENT OF OCTOBER FOR THE VANDERBILT CUP. THE DOTTED ROAD SHOWS THE ROUTE TO THE GRAND STAND. THE TRIAL IS FOR TEN CIRCUITS, 297.1 MILES.

For the third time in as many years, drivers in the 1906 Vanderbilt Cup Race faced a new course layout. The construction of a new trolley line stretching from Queens to Mineola forced a redesign of the western section of the course from its 1905 configuration. The grandstand returned to its 1904 site on Jericho Turnpike in Westbury. The first 12 miles of the new 29.7-mile course were unaltered from 1905, including the turns at Jericho, East Norwich, and Bull's Head Hotel in Greenvale. The remaining 17.7 miles presented hilly sections and more challenging turns than drivers had seen before. After heading south on Glen Cove Road, the revised course included a hairpin turn in Old Westbury, two new turns in Roslyn, the challenging hills in Manhasset Valley, and two more turns in Lakeville. The final challenges were a turn at Krug's Hotel in Mineola and a nearby railroad crossing heading back east on Jericho Turnpike. In all, the course presented 11 turns per lap or a total of 110 during the 10-lap, 297-mile race.

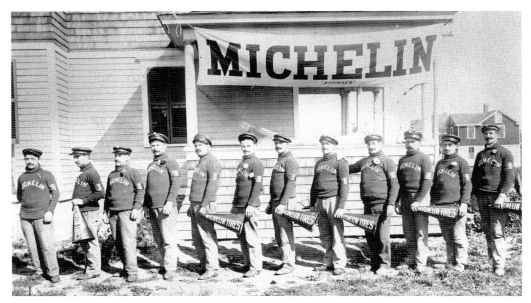

In addition to the car manufacturers, tire companies like Michelin positioned service stations around the course. These crews supported the teams that used their products if they suffered a tire failure during the race. They typically wore distinctive wool sweaters with their company name. (Courtesy of the Suffolk County Vanderbilt Museum.)

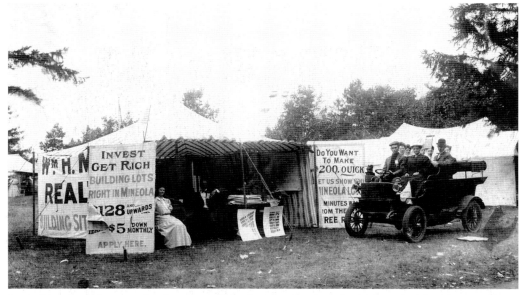

Long Island residents took advantage of the large gathering of people to market their products and services. Tents near the grandstand promoted Long Island real estate and automobiles and sold food. Customers were encouraged to "Invest Get Rich" by purchasing Mineola building lots for "$128 and more." This land is likely worth well over $100,000 today. (Courtesy of the National Automotive History Collection at the Detroit Public Library.)

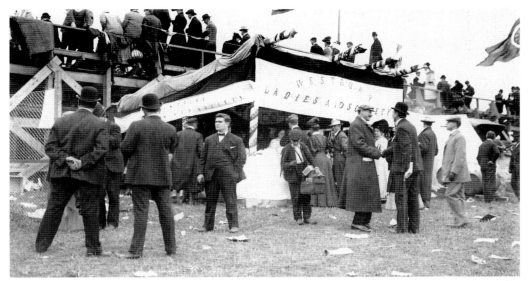

The 1906 grandstand was built with a capacity to accommodate 2,100 spectators. Behind the grandstand, the Westbury Ladies Aids Society sold sandwiches and refreshments. As with the 1905 race, a two-sided scoreboard was placed on top of the press and officials stand directly in front of the grandstand. (Courtesy of the National Automotive History Collection at the Detroit Public Library.)

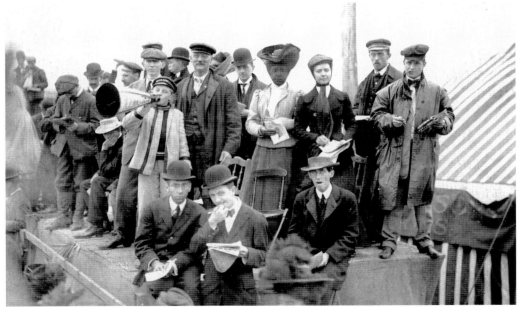

Beyond the grandstands, smaller unofficial stands constructed by local residents sprouted up around the course. This was another opportunity for Long Islanders to sell their services to spectators. The boy on this grandstand is rooting for his favorite drivers with a megaphone. (Courtesy of the National Automotive History Collection at the Detroit Public Library.)

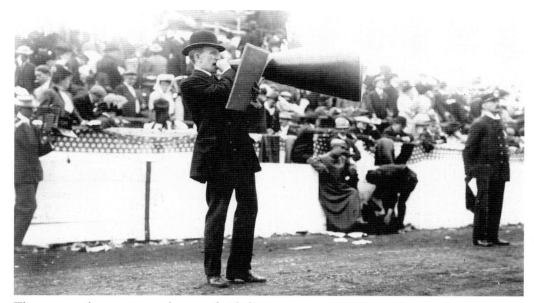

The center of attention at the start-finish line was announcer Peter Prunty, who wielded an imposing megaphone more than a yard long. He was the public address system for every Long Island Vanderbilt Cup Race, relaying messages telephoned in from throughout the course. (Courtesy of the National Automotive History Collection at the Detroit Public Library.)

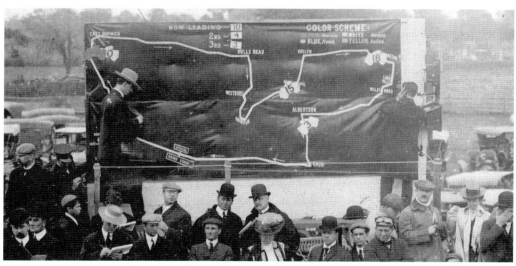

New for the grandstand area was a large green map with the course outlined in white. It sat atop the grandstand and was used to help observers follow the race. Color-coded cardboard icons of race cars—red for America, blue for France, white for Germany, and yellow for Italy—were moved about on wooden pegs to indicate where cars were on the course. The map was a curiosity in that it was printed backward, as photographic evidence clearly proves. For example, East Norwich, located on the east section of the course, was shown above on the west side of the map. (Courtesy of the Henry Ford.)

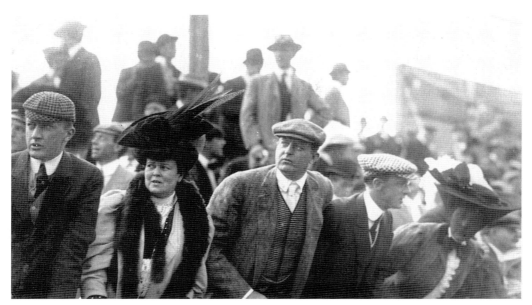

William K. Vanderbilt Jr.'s mother, Alva (second from left), and his step-father, O. H. P. Belmont (third from left), watch the race from their front-row box seats. Alva was a regular attendee at her son's races and always attracted visitors to her box seats just in front of the course. (Courtesy of Brown Brothers.)

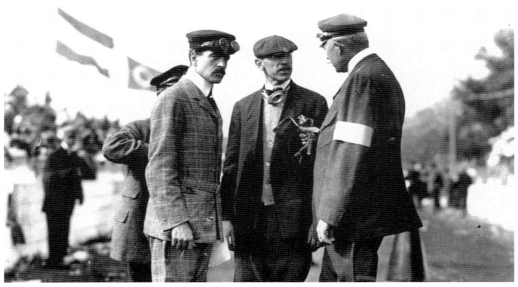

As the scheduled 6:00 a.m. start time approaches, referee William K. Vanderbilt Jr. (left) confers with his longtime trusted aide and associate referee A. R. Pardington (center) and AAA Racing Board chairman Jefferson DeMont Thompson. Factoring reports from around the course that fog hung dangerously low, limiting visibility, they decided to delay the start by 15 minutes. (Courtesy of Brown Brothers.)

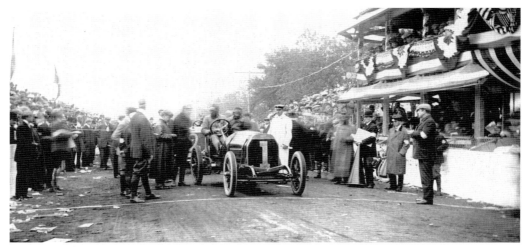

Red-bearded Frenchman Hubert LeBlon (left), driving the red American 115-horsepower No. 1 Thomas, is in the first car lined up to start the race. Peter Prunty (standing to the right of the car) announced LeBlon, and the race was ready to begin. Riding mechanician Marius Amiel cranked the motor, and a healthy roar ignited. At 6:15 a.m., starter Fred Wagner (standing to the left of the car) shouted "Partez," and the Frenchman was away. Wagner took great pride in speaking the language of each driver. The Thomas roared off in good order, drawing applause from the partisan American crowd. (Courtesy of Brown Brothers.)

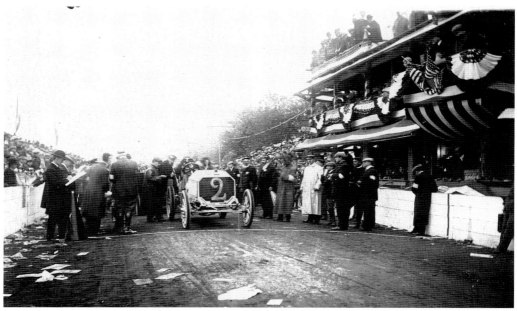

A minute later, 1904 winner George Heath was given the signal to depart in his new, blue, more powerful 120-horsepower No. 2 Panhard. Heath was clad in rubber-coated garments with a handkerchief knotted around his neck. To the right of the car, the three-level press and officials stand is covered with red, white, and blue bunting. (Courtesy of Brown Brothers.)

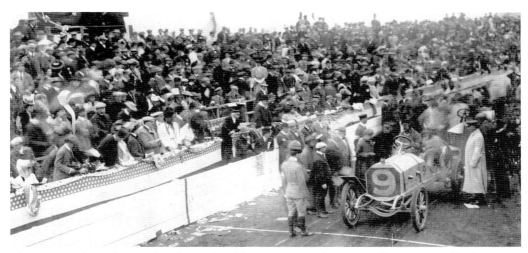

There were high hopes for driver Joe Tracy in the American Elimination Trial winner 90-horsepower No. 9 Locomobile as he waited on the starting line. Referee William K. Vanderbilt Jr. can be seen standing to the left of the car. Perhaps portending his final result, Tracy's machine faltered briefly before disappearing from view. The Locomobile was never to be a factor in the race. A miserable series of tire failures put Tracy hopelessly behind. The lone bright spot for the Americans came when Tracy averaged 67.7 miles per hour on the fifth lap, the fastest speed of any car in the race. (Courtesy of the Henry Ford.)

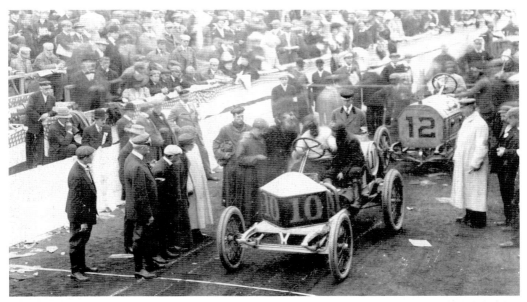

Louis Wagner (left) and riding mechanician Louis Vivet prepare to begin the race in the French 100-horsepower No. 10 Darracq. The *Motor Way* called the car "the peculiar wire wheeled, little Darracq." Behind Wagner is the gray Italian No. 12 Itala driven by Alessandro Cagno. Foxhall Keene's No. 11 Mercedes was absent as it had failed to start due to cracked cylinders discovered shortly before practice began. (Courtesy of the Henry Ford.)

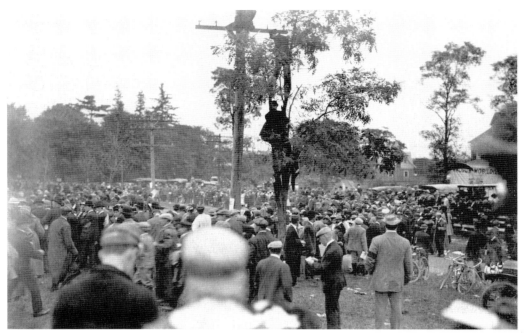

The drivers were immediately unnerved by the large number of spectators throughout the course. Crowds were particularly heavy at the major turns on the course, as seen here at the Old Westbury hairpin turn at the intersection of Wheatley Road and Old Westbury Road. Note the men on the telephone pole hoping to gain a better vantage point to view the race. (Courtesy of the National Automotive History Collection at the Detroit Public Library.)

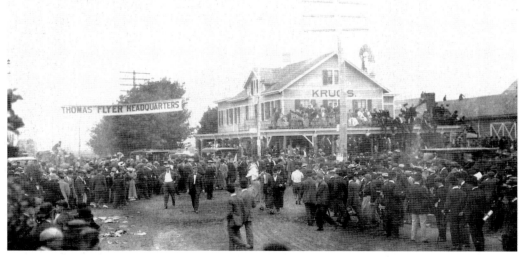

Trade magazine *Motor World* called the Jericho Turnpike section of the course "that living, craning, waving lane from Mineola to the stand." As the race began, spectators broke through six-foot protective fences at Krug's Hotel in Mineola to venture onto the road. (Courtesy of the National Automotive History Collection at the Detroit Public Library.)

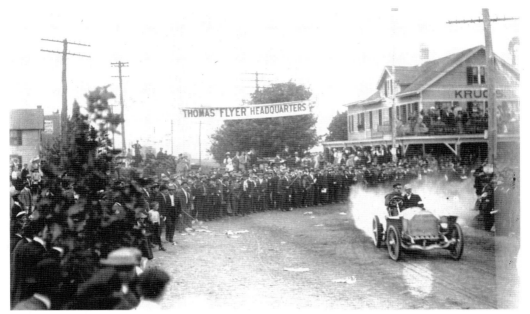

With a cry of "Hundreds are going to be killed if the crowd is not controlled," Locomobile driver Joe Tracy pulled to a stop to warn race officials after completing his first lap. Referee William K. Vanderbilt Jr. jumped into his Mercedes with race chief surgeon Louis Lanehart and made one fast lap to check out crowd conditions and to clear the course. The crowd temporarily returned to positions behind the fences surrounding Krug's Hotel. (Courtesy of the Henry Ford.)

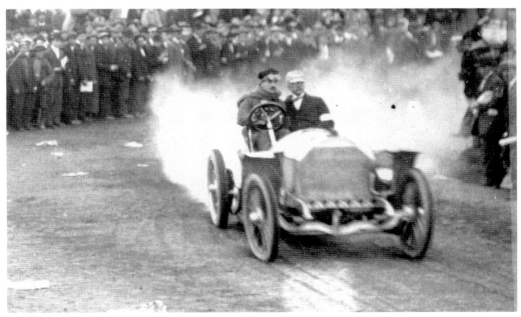

Seen here are referee William K. Vanderbilt Jr. (left) and race chief surgeon Louis Lanehart. (Courtesy of the Henry Ford.)

Despite its appearance on the map, the Old Westbury hairpin turn on the corner of Wheatley Road and Old Westbury Road was more sweeping than racers expected. Named because its contour was reminiscent of the bend of a hairpin, it actually presented less of a challenge to the drivers than other turns, such as Krug's Corner. (Courtesy of Brown Brothers.)

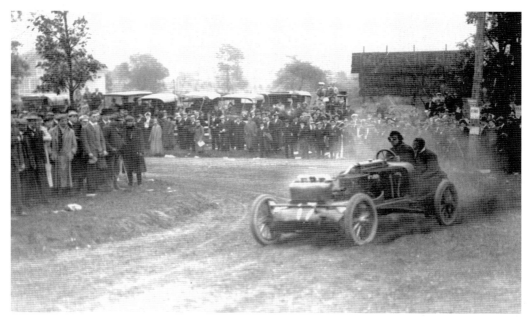

The blue, unique, 50-horsepower, front-wheel-drive No. 17 Christie, driven by its designer Walter Christie, speeds around the hairpin turn. Most of the Old Westbury spectators probably did not appreciate the danger, but more than 2,000 people risked their lives crowding the course on the turn. (Courtesy of the Henry Ford.)

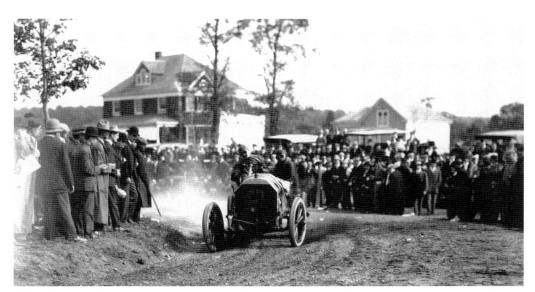

Felice Nazzaro also soared in his Italian 120-horsepower No. 8 Fiat at the hairpin turn, perilously close to the spectators. The Italian star was the fastest car on the course on both laps 8 and 9 but suffered tire failures and finished the race in sixth place. (Courtesy of the National Automotive History Collection at the Detroit Public Library.)

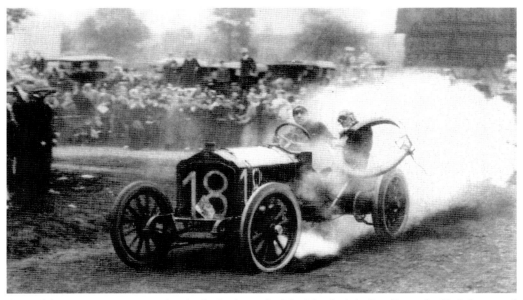

One of the stirring moments that built the legend of the Vanderbilt Cup Race thrilled the crowd at the hairpin turn. A spare tire and rim strapped to the back of the No. 18 Lorraine-Dietrich broke loose and began to thrash the gas tank. Riding mechanician Franville clutched the heavy mounted tire and lost his balance. Just as the car skidded through the turn, the French driver Arthur Duray handled the tight corner with one hand on the wheel while rescuing his assistant with his left arm.

At the base of Spinney Hill in Manhasset Valley, a 500-person grandstand was constructed to view the action on the North Hempstead Turnpike. (Courtesy of the National Automotive History Collection at the Detroit Public Library.)

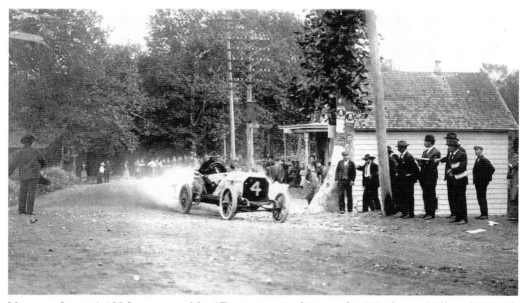

Vincenzo Lancia's 120-horsepower No. 4 Fiat maintained its speed up Manhasset Hill on the North Hempstead Turnpike, one of the more challenging portions of the course. The hill presented a steep upgrade for about one and a half miles. Based on his spirited performance in 1905, Lancia was a crowd favorite and received a resounding round of applause from the grandstand crowd at the start and at the Spinney Hill grandstand. (Courtesy of Brown Brothers.)

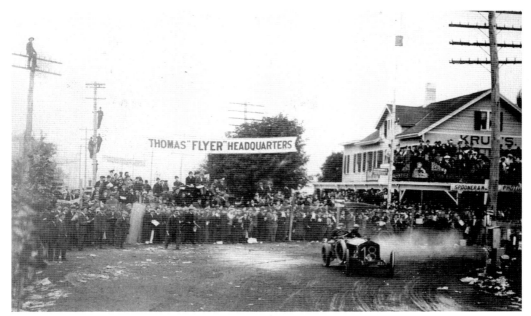

Arthur Duray, driving his No. 18 Lorraine-Dietrich, passes a huge crowd at Krug's Hotel in Mineola. The Krug's Corner crowd was restrained from entering Jericho Turnpike and Willis Avenue by a six-foot wire fence. (Courtesy of the Henry Ford.)

The unruliness of the crowd was not limited to those running out on the course. Many men scaled and perched on telegraph poles to obtain excellent views of the race. This gentleman is quite satisfied with his vantage point at Krug's Corner. (Courtesy of Brown Brothers.)

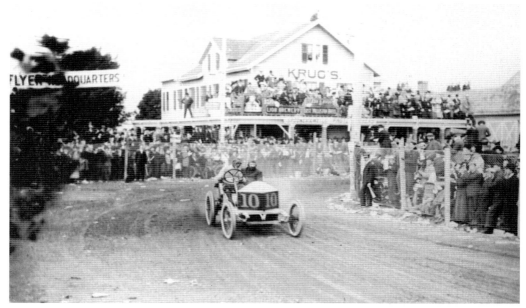

Louis Wagner in his No. 10 Darracq rounds Krug's Corner. As the race wore on, impatient and foolhardy spectators once again pushed through the fencing around the hotel and on the north side of Jericho Turnpike. (Courtesy of the Henry Ford.)

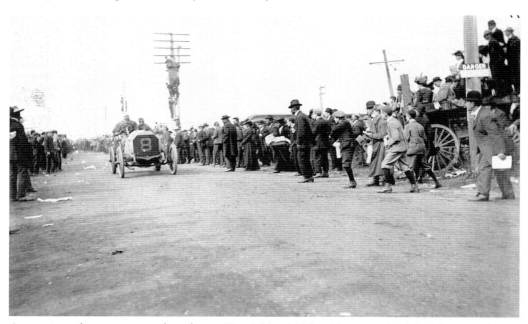

Approximately one quarter of a mile past Krug's Hotel, Felice Nazzaro in his No. 8 Fiat speeds past the only railroad grade crossing on the course on Jericho Turnpike in Mineola. At the crossing, the Long Island Rail Road placed a stopped train for its guests to view the race. (Courtesy of the Collections of the New Jersey Historical Society, Newark, New Jersey.)

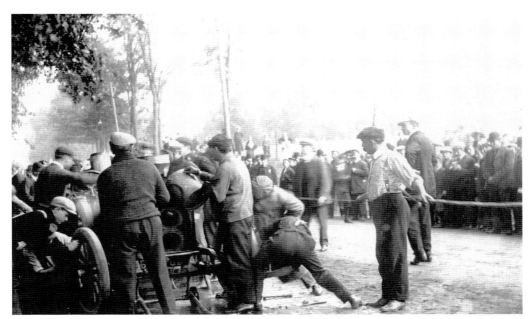

A four-minute planned service stop slowed Arthur Duray's No. 18 Lorraine-Dietrich considerably on lap 8. The delay dropped him from third to fourth place behind Camille Jenatzy's Mercedes. (Courtesy of the Henry Ford.)

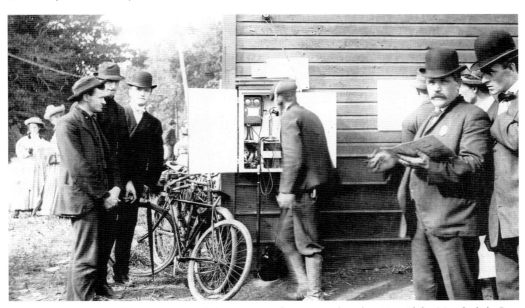

Telecommunication, like the automobile, was a modern marvel at the time of the Vanderbilt Cup Races. Hundreds of miles of telephone wire were installed to numerous points around the course to connect call-in stations to the press and officials stand at the start-finish line. Observers called in reports from remote portions of the course to help officials track the progress of cars in the race. (Courtesy of the National Automotive History Collection at the Detroit Public Library.)

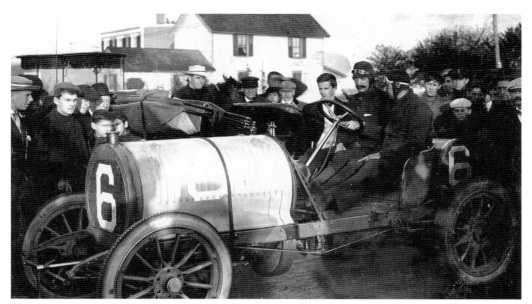

Elliot F. Shepard Jr., a 30-year-old American and William K. Vanderbilt Jr.'s cousin, drove the most powerful car in the race, a French 130-horsepower French Hotchkiss. Shepard did not realize that he would soon become the center of controversy for the 1906 race. (Courtesy of Brown Brothers.)

The European cars, including the No. 6 Hotchkiss, featured a new removable rim technology, which enabled their tires to be changed several times faster than those cars with fixed rims. (Courtesy of the Suffolk County Vanderbilt Museum.)

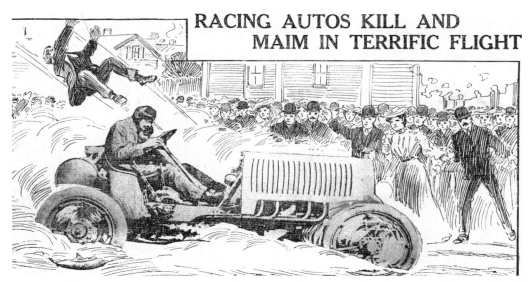

Just one of the many spectators persistently crowding the course, Curt Gruner, a 33-year-old mill foreman from Passaic, New Jersey, pressed his luck too far in 1906. Slightly to the east of the Long Island Rail Road crossing on Jericho Turnpike near Krug's Hotel, Gruner found himself in the wrong place at the wrong time. Elliot F. Shepard Jr.'s Hotchkiss struck him down on lap 6, killing the unfortunate man.

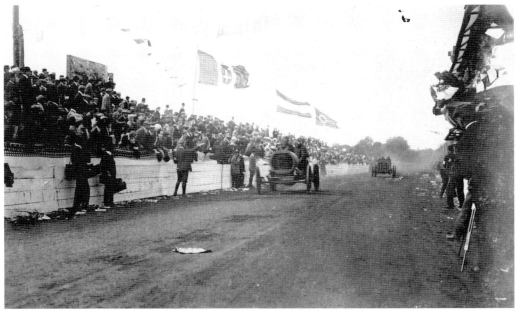

Not realizing he struck Gruner, Shepard continued at speed down Jericho Turnpike to the grandstand where he battled Duray's No. 18 Lorraine-Dietrich. However, after just a few miles, he stopped at East Norwich and discovered a broken crankshaft. When informed about the fatality, a distraught Shepard retired from the race. (Courtesy of the Henry Ford.)

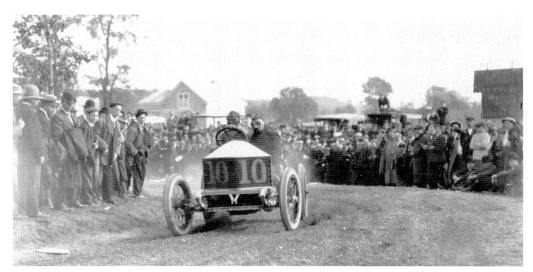

The race was dominated by Louis Wagner's Darracq, which led from start to finish. Wagner described the challenge that he faced at the Old Westbury hairpin turn during the final lap: "There was no stopping or slackening at the turn, no further fear or concern over the reckless crowds that, by this time, were pressing so far on the course that for many miles there was only a narrow lane open between staring human wall." (Courtesy of the National Automotive History Collection at the Detroit Public Library.)

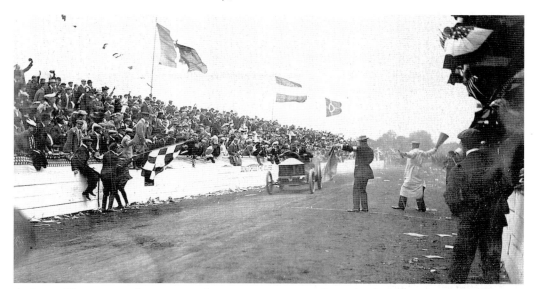

As Louis Wagner was about to win the contest, starter Fred Wagner waved what is believed to be the first checkered flag used to signify the finish of an automobile race. Standing on the railing above the flag, William K. Vanderbilt Jr. saluted the victor. The winning Darracq averaged 62.7 miles per hour over the 297.1-mile race. Vincenzo Lancia's Fiat finished second, only 3 minutes and 18 seconds behind, followed 16 seconds later by Arthur Duray's Lorraine-Dietrich. (Courtesy of Brown Brothers.)

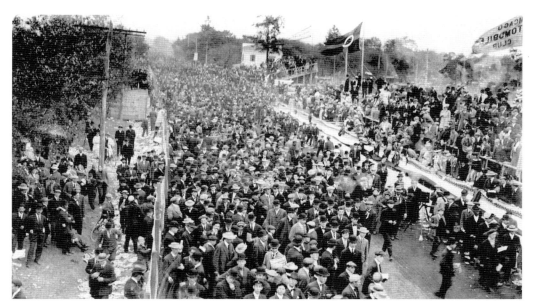

More than 200,000 spectators attended the race, breaking the attendance record set at the 1905 race. After the race was called, the crowd once again filled Jericho Turnpike around the grandstand. (Courtesy of the National Automotive History Collection at the Detroit Public Library.)

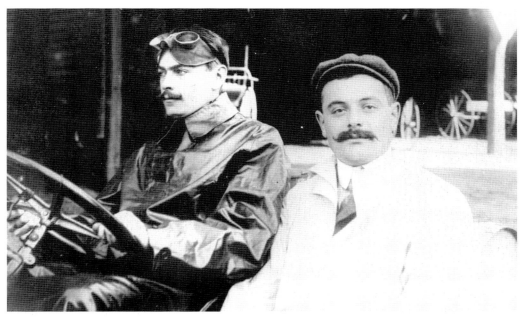

The victory of driver Louis Wagner (left) and his riding mechanician Louis Vivet was the third consecutive win for France. Wagner called the race "certainly the most nerve-wrenching contest in motoring history" and later wrote a magazine article about the horror of racing through roads crowded with people. (Courtesy of the Helck family collection.)

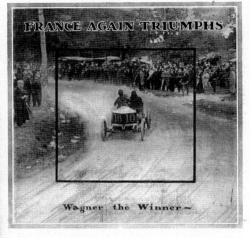

The 1906 Vanderbilt Cup Race created a kind of dichotomy of perspective in the press. Most agreed the race produced exciting entertainment, but they also condemned the lack of crowd control and unnecessary risk to human life. The *Horseless Age* called the race "the greatest sporting event in America." Conversely, the *Chicago Tribune* reported, "Seventeen cars traveling at the speed of a cyclone, swept around a 29 mile course for the glory of the Vanderbilt Cup. The trail of dead and maimed left in their smoke makes it almost certain that the mad exhibition of speed will be the last of its kind the country will witness."

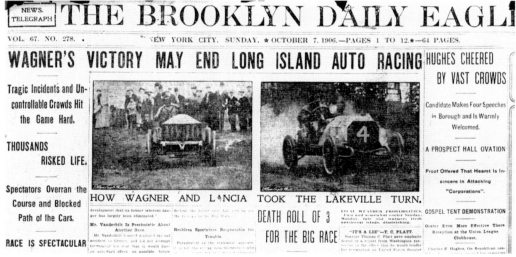

While the press praised the entertainment value of the race, the death to a spectator also fueled editorials crying for crowd control reform. The bone of contention was the continued use of public roads. Two days after the race, AAA president John Farson appointed a special committee to look into developing a privately owned speedway. At an October 18, 1906, meeting, William K. Vanderbilt Jr. was named president of a newly formed Automobile Highway Association. The company would later become Long Island Motor Parkway, Inc., responsible for developing the first road built specifically for the automobile.

5

LONG ISLAND MOTOR PARKWAY

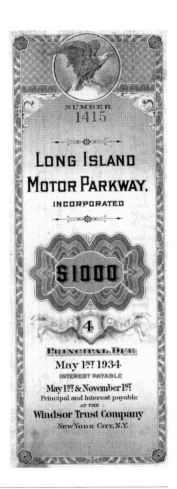

With great promise and fanfare, Long Island Motor Parkway, Inc., was capitalized with $2 million in December 1906. A frustrating series of setbacks in obtaining rights-of-way to privately owned property resulted in a steady series of missed project milestones. Eventually the Vanderbilt Cup Commission was forced to cancel the 1907 race and Long Island Motor Parkway, Inc., delayed construction until 1908. Issued on November 16, 1906, a prospectus for the Long Island Motor Parkway proclaimed the company's visionary operating plans and projected a positive outlook for success. The document described a grand thoroughfare that would boost real estate values, create jobs, and fuel the Long Island economy. It called for a high-speed link 100 feet wide and 50 miles long to start in New York and end near Riverhead in Suffolk County.

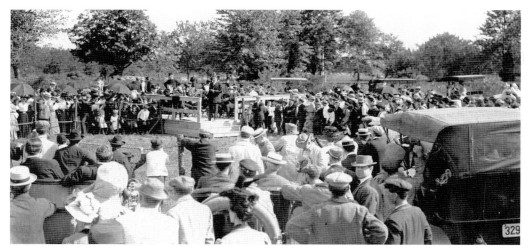

Several hundred people attended the June 6, 1908, groundbreaking ceremony to commemorate the construction of the Long Island Motor Parkway. Guests of honor sat in what newspapers called a "rough grandstand" of wood planks at Jerusalem Road in Central Park east of Mineola. William K. Vanderbilt Jr. had planned to perform the ceremonial turn of sod with a gold-plated shovel and make a speech, but the sudden and fatal illness of his stepfather, O. H. P. Belmont, drew him away. (Courtesy of the National Automotive History Collection at the Detroit Public Library.)

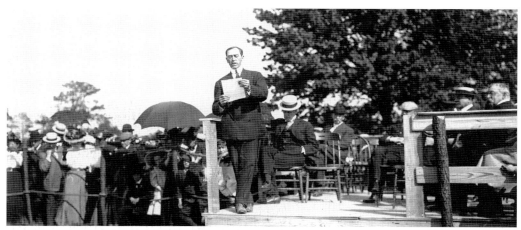

A. R. (Arthur Rayner) Pardington, the general manager for the Long Island Motor Parkway, filled in for Vanderbilt, reading from remarks Vanderbilt had written to mark the occasion. The comments praised the impact and potential of the automobile and reflected on unforeseen obstacles that had impeded the parkway's progress. "The automobile has come into such prominence that it has revolutionized all mode of travel. Distance has been eliminated, highways improved, unknown districts opened up, and pleasure given to thousands . . . land owners in almost every case, seeing what a benefit a road of this character would be to their property, gladly came forward with help, enabling us to complete a forty-five mile right of way." (Courtesy of the National Automotive History Collection at the Detroit Public Library.)

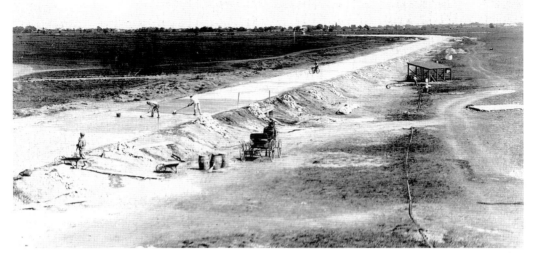

Plans called for 11 miles of the Long Island Motor Parkway to be completed by October 1908 for use in combination with public roads for the Vanderbilt Cup Race course. By September 1908, it was clear only eight miles would be available. Still, excitement ran high as predictions of sizzling speeds of over 100 miles per hour proliferated. (Courtesy of the National Automotive History Collection at the Detroit Public Library.)

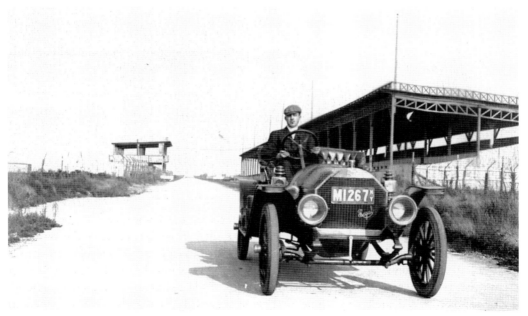

As the construction of the Long Island Motor Parkway progressed, officials tested its running surface. While Vanderbilt's vision originally called for a course 100 feet wide, the end product was less than a quarter of that at 22 feet wide. (Courtesy of Brown Brothers.)

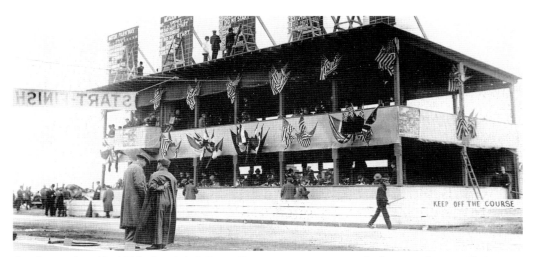

On September 10, 1908, the AAA Race Commission announced plans to christen the motor parkway with an event called the Motor Parkway Sweepstakes. Five concurrent stock car races were scheduled for October 10, 1908. The idea was to create an opportunity to test the new course, timing systems, and crowd control for the Vanderbilt Cup Race scheduled two weeks later. Officials of the sweepstakes meet in front of the new double-decker press and officials stand on race day. (Courtesy of the National Automotive History Collection at the Detroit Public Library.)

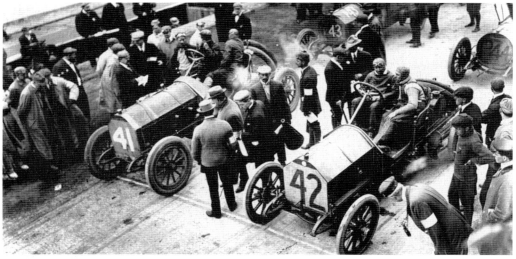

Starter Fred Wagner lined the 32 starters in rows of two in front of the Hempstead Plains grandstand. The smallest cars started first, leading up through the five classes of automobiles. The car classifications were designated with a letter next to the number of the car with N for Nassau, J for Jericho, G for Garden City, M for Meadow Brook, and P for Parkway. Among the motor parkway sweepstakes competitors were William Haupt's No. P41 Chadwick, Herb Lytle's No. P42 Isotta, Frank Lescault's No. P43 Simplex, and J. Kilpatrick's No. P44 Hotchkiss. (Courtesy of Brown Brothers.)

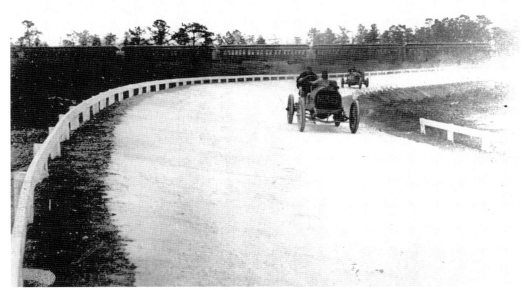

During the sweepstakes races, Axel Peterson's Rainier No. M36 battles William Haupt's Chadwick No. P41 at "Deadman's Curve" in Central Park, now Bethpage. A Long Island Rail Road train can be seen in the background. (Courtesy of the Suffolk County Vanderbilt Museum.)

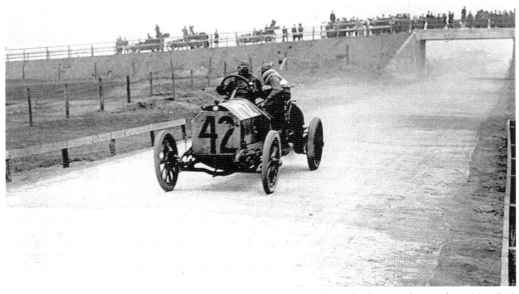

The winner of the Motor Parkway Sweepstakes was Herb Lytle driving his Italian No. P42 Isotta at an average speed of 64.25 miles per hour, an American record for long-distance speed contests. As Lytle drives past the newly constructed Jerusalem Road Bridge over the Long Island Motor Parkway, his riding mechanician looks back toward the grandstand. The grandstand can be seen through the bridge passageway. (Courtesy of the Suffolk County Vanderbilt Museum.)

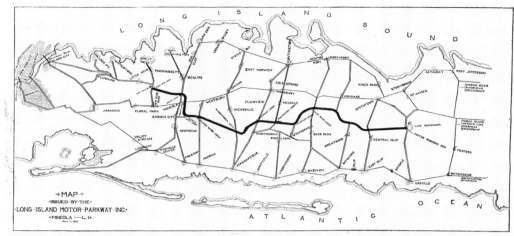

The World's Modern Appian Way—The Long Island Motor Parkway

The Long Island Motor Parkway was initially promoted as "the World's Modern Appian Way," a moniker first presented to the public in a *Harper's Weekly* article written by A. R. Pardington in March 1907. Vanderbilt and his associates were careful to position the motor parkway as not primarily a speedway for race cars but a modern convenience to all automobile enthusiasts. They extolled the virtues of economic development and the efficiency of quickly retreating from the city to the calm and healthful benefits the fresh country air of Long Island had to offer.

The Long Island Motor Parkway would eventually connect Fresh Meadows, Queens, to Lake Ronkonkoma in Suffolk County, a total of 48 miles. A 5-by-5-inch porcelain annual-fee plate was issued to permit unrestricted year-round use on the parkway. No. 100 was assigned to William K. Vanderbilt Jr. Reflecting its poor profitability and the availability of new free public parkways, the Long Island Motor Parkway closed for good on Easter Sunday 1938. (Courtesy of the Suffolk County Vanderbilt Museum.)

6

The 1908 Vanderbilt Cup Race

Due to a dispute between the Automobile Club of America (ACA) and AAA, the 1908 Vanderbilt Cup Race attracted little interest from the European automobile companies. Because of the ACA's strong affiliation with the International Committee of Recognized Auto Clubs, the Europeans preferred to compete in the International Road Race for the Grand Prize of the ACA that was held in November 1908 in Savannah, Georgia. Fortunately, the AAA and ACA struck a compromise in their power struggle and eventually cooperated to make both races a success.

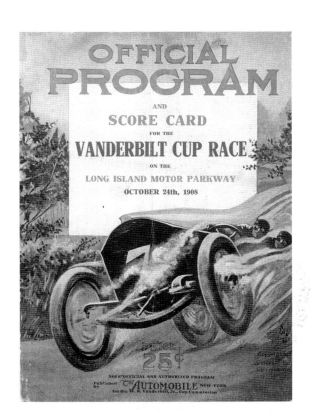

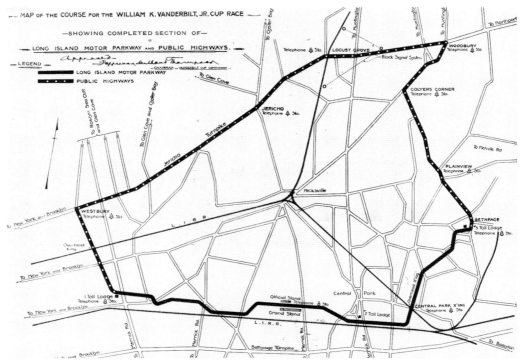

The 1908 course was finalized in late September, including only eight miles of the Long Island Motor Parkway and 11 new motor parkway bridges over and under public roads. The remainder of the course was 15.46 miles of public roads, primarily Round Swamp Road, Plainview Road, Jericho Turnpike, and Ellison Avenue. The Vanderbilt Cup Commission of the AAA announced the race would consist of 11 laps or 258.06 miles to be held on Saturday, October 24, 1908.

Much maligned for its slow service, the Long Island Rail Road still transported the majority of spectators from New York City and Brooklyn to the races. At midnight on the day of the race, hourly trains would bring people to a special makeshift stop in the Hempstead Plains, approximately a quarter of a mile from the grandstand. (Courtesy of the National Automotive History Collection at the Detroit Public Library.)

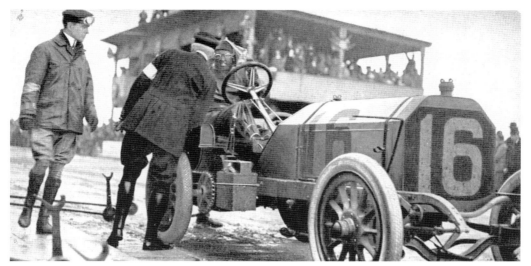

William K. Vanderbilt Jr. took his role of referee very seriously and at times seemed ubiquitous. When driver George Robertson (right) and riding mechanician Glenn Ethridge stopped the No. 16 Locomobile to strap in a spare tire, Vanderbilt (left) and Jefferson DeMont Thompson, chairman of the 1908 Vanderbilt Cup Commission, inquired about road conditions. Robertson was wearing a racing mask and a scarf on his cap to clean his goggles.

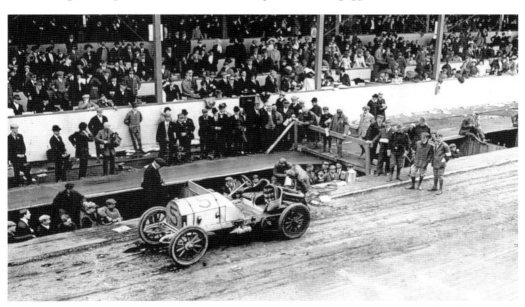

At the end of lap 9, driver William Luttgen stopped the No. 5 Mercedes owned by William K. Vanderbilt Jr. to change the right rear tire at the service pits located in front of the grandstand. Luttgen and his riding mechanician quickly refreshed themselves with a bottle of wine and then jumped back into the heat of the battle. This was the only time Vanderbilt officially entered a car in the race, and he probably did so due to the low car count as a result of the protracted battle with the ACA.

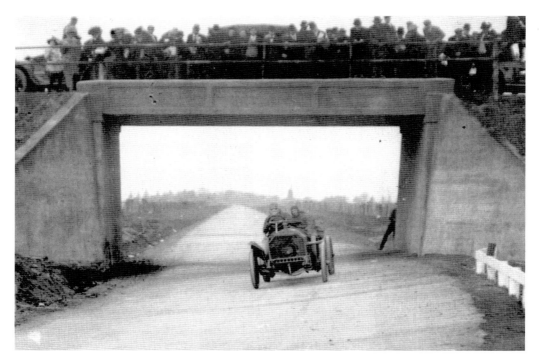

Running second, Emil Stricker drives the No. 3 Mercedes under the Carman Avenue Bridge in East Meadow during lap 5. However, a broken fan blade gashed the radiator, and the engine overheated on lap 10. Stricker finished in sixth place. (Courtesy of the Henry Ford.)

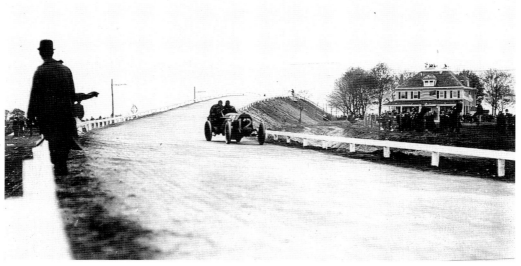

George Salzman in the No. 12 Thomas is going about 65 miles per hour while navigating the Long Island Motor Parkway's Newbridge Road Bridge. Spectators watch from the roof of the Newbridge Hotel, which is covered with American flags to celebrate the race.

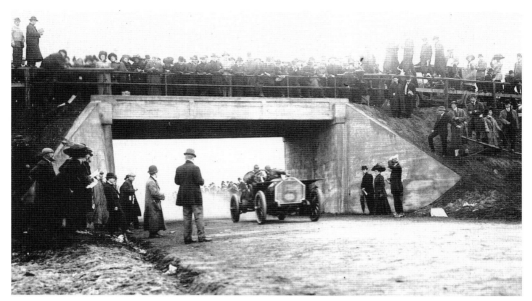

Spectators on the Jerusalem Avenue Bridge watch Herb Lytle's Italian Isotta challenge for the lead. Lytle put up a game fight in this stock car, finishing second. This was the same Isotta Lytle drove to victory in the Motor Parkway Sweepstakes. (Courtesy of the National Automotive History Collection at the Detroit Public Library.)

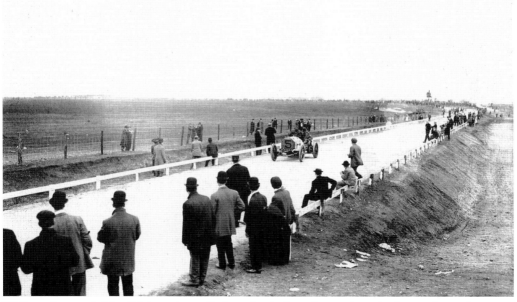

William Luttgen's No. 5 Mercedes pulled to third place during lap 10 after making the curve past the Jerusalem Avenue Bridge on the Long Island Motor Parkway. (Courtesy of the National Automotive History Collection at the Detroit Public Library.)

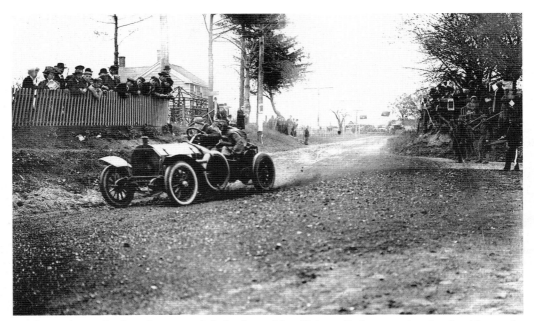

At the Bethpage Lodge, the course left the Long Island Motor Parkway and utilized public roads. Emil Sticker in the No. 3 Mercedes is seen speeding down Plainview Road. (Courtesy of the National Automotive History Collection at the Detroit Public Library.)

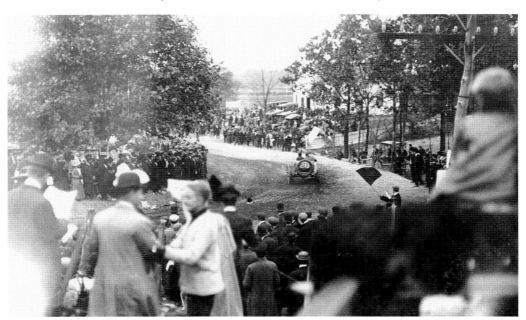

William Borque in the No. 20 Knox skids through the Woodbury turn onto Jericho Turnpike. Tragically, Borque would lose his life in a racing accident the following year in 1909, becoming the first driver to be fatally injured at the Indianapolis Motor Speedway. (Courtesy of the Helck family collection.)

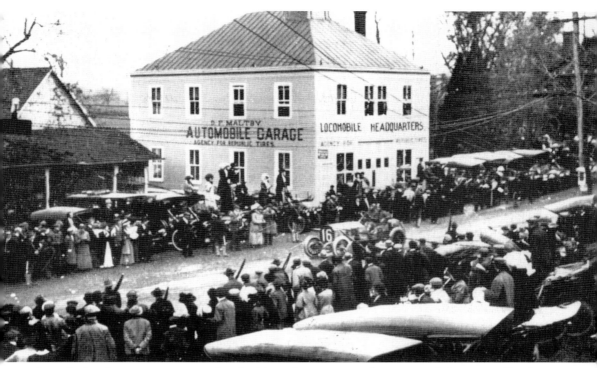

As with the three previous races, Jericho Turnpike was a significant part of the course. For the 1908 race, the cars traveled east to west down the turnpike for the first time. Jericho residents were thrilled when George Robertson drove his No. 16 Locomobile past the team's headquarters located in D. F. Maltby's automobile garage. The building would later become Jericho's first firehouse. The Irish Volunteers, a private militia organization, was contracted to guard the course and can be seen above on the east side of the road. Despite being uniformed in blue coats and armed with muskets, they were criticized in the press as "comic opera guards" and "neither militant or military." (Courtesy of the National Automotive History Collection at the Detroit Public Library.)

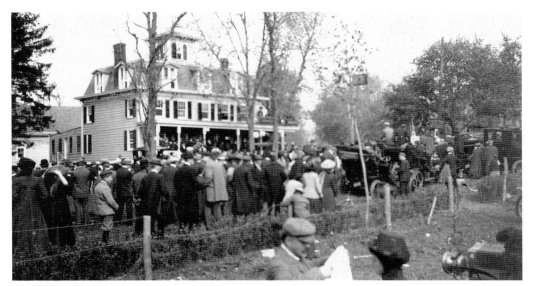

Located right next door to the Locomobile headquarters, the Victorian early-20th-century-style W. B. Powell's Jericho Hotel was once again a favorite gathering place for spectators. (Courtesy of Nassau County Department of Parks, Recreation and Museums–Cedarmere.)

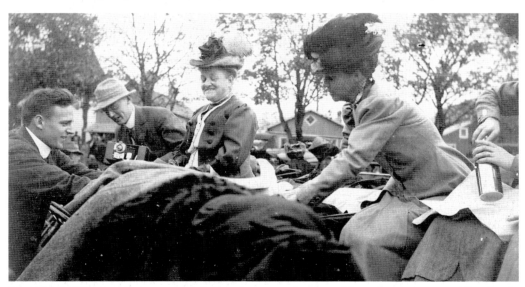

The Vanderbilt Cup Race never failed to draw people of wealth and social status. The family of noted poet and *New York Evening Post* editor William Cullen Bryant (1794–1878) enjoy a picnic in Jericho at the races. From left to right are Bryant's great-grandson Frederick Marquand Godwin and his cousin Conrad Godwin Goddard, Bryant's granddaughter Fanny Godwin White, and Elizabeth Marquand Godwin, Frederick's wife. The woman holding the thermos (far right) is Frederick's sister Elizabeth Love Godwin, a great-granddaughter of Bryant. Fanny Godwin White was the first woman to obtain an automobile license in Roslyn. (Courtesy of Nassau County Department of Parks, Recreation and Museums–Cedarmere.)

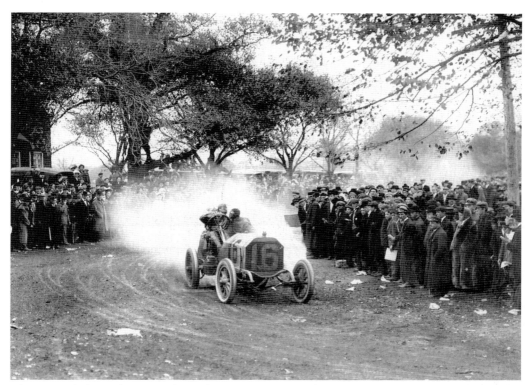

The course left Jericho Turnpike at the intersection of Elliston Avenue in Westbury. In a classic Vanderbilt Cup Race moment, George Robertson in the No. 16 Locomobile storms through the Westbury turn as hoards of people line the course. (Courtesy of Brown Brothers.)

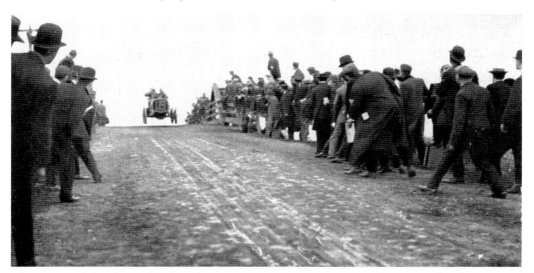

The Locomobile, the pride of Bridgeport, Connecticut, soars over the Long Island Rail Road Bridge on Elliston Avenue in Westbury. Driver George Robertson is running fast enough for the car's wheels to clear the running surface as it crests the peak of the bridge.

VANDERBILT CUP RACES OF LONG ISLAND

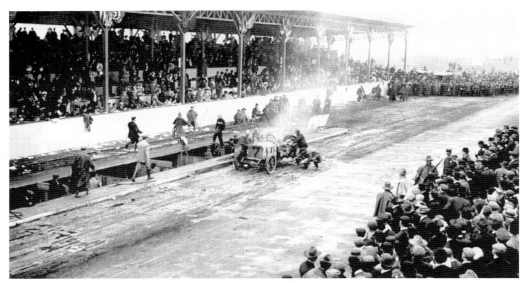

James Ryall's No. 7 Matheson retired from the race in spectacular fashion. At the end of lap 4, he slowed his smoking racer and gave grandstand spectators a thrill when flames leapt from under the engine cowling. A flaw in design had placed the carburetor too close to the red-hot exhaust, and fuel splashed out of it when he shot over Newbridge Road Bridge at full speed. The errant fuel ignited and was extinguished at the grandstand pits.

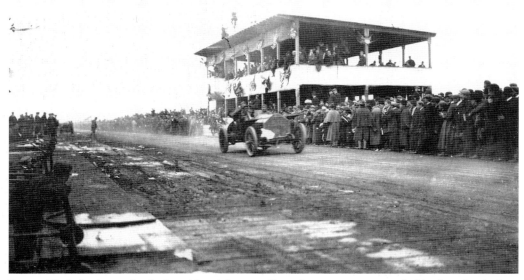

Driver Herb Lytle in the Italian No. 6 Isotta adhered to a strategy much like his third-place finish with the underpowered Pope-Toledo in the 1904 race. He drove a steady, determined race, keeping the leader in sight and depending on attrition to help him win the day. His strategy nearly paid off when George Robertson in the Locomobile skidded off the track on the final lap. As Lytle started his final lap, he was running second.

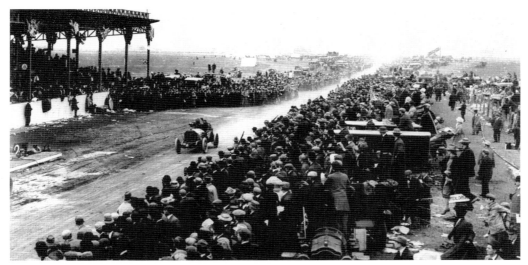

With a lead of over four minutes, Robertson's No. 16 Locomobile began the final lap of the race apparently on his way to an easy victory. However, instead of taking a conservative pace, Robertson pushed so hard he lost control and skidded backward off Plainview Road and destroyed one of his tires. Amazingly, the car was otherwise undamaged. Robertson's place in history hinged on his skills and those of his riding mechanician Glenn Ethridge in changing the tire. In a swift 2 minutes and 10 seconds, a new tire was mounted on the rim. (Courtesy of Brown Brothers.)

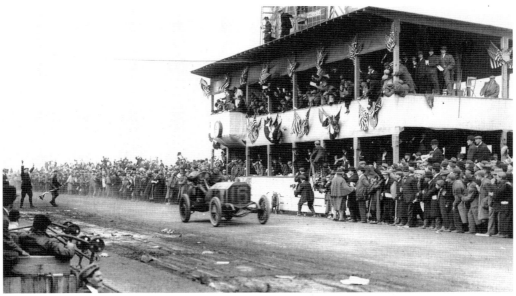

Robertson drove the big Locomobile across the line to claim the 1908 Vanderbilt Cup. For the first time, America could finally boast victory in an automobile race against international competition. Robertson averaged 67.3 miles per hour and finished 1 minute and 48.2 seconds ahead of the Herb Lytle's Italian Isotta. (Courtesy of Brown Brothers.)

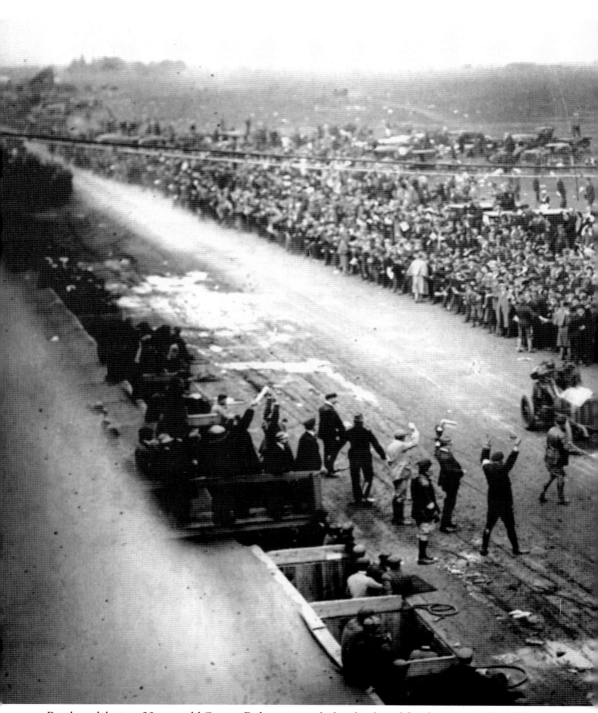

Brash and daring, 23-year-old George Robertson took the checkered flag from starter Fred Wagner before a huge crowd in the Hempstead Plains (now Levittown). Jefferson DeMont Thompson, chairman of the race commission, is seen with his hands raised. Beside him to his left is the

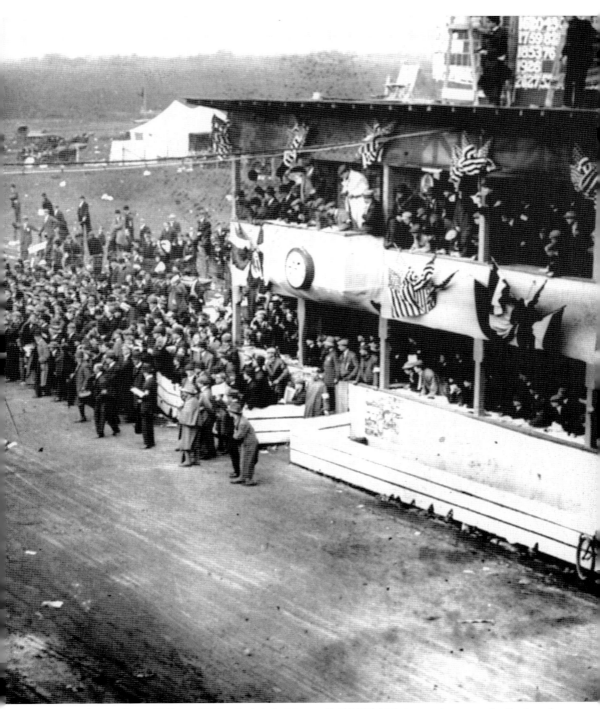

ever-vigilant referee William K. Vanderbilt Jr. Now called "Old 16," the car is currently displayed at the Henry Ford Museum in Dearborn, Michigan. (Courtesy of Brown Brothers.)

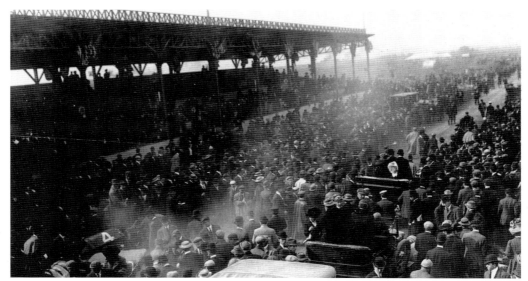

The scene was pandemonium after George Robertson won the race. Typical of crowds immediately following the declaration of a winner, people swarmed the road to head home or surround the winning car. The race was officially called off at 10:55 a.m., and telephone calls went out to signalmen to display white danger flags to waive off the remaining nine cars still on the course. (Courtesy of the National Automotive History Collection at the Detroit Public Library.)

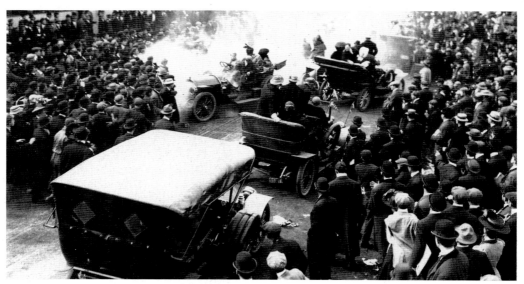

Running in third place behind Robertson and Herb Lytle, Jim Florida, driver of the No. 1 Locomobile, did not get word to stop and plunged his car into the throng at the start-finish line. Note the smoke at the scene of the accident. Florida struck and injured an 18-year-old boy and then hit a touring car. Fortunately, none of the occupants of the touring car were injured and the boy recovered. (Courtesy of the National Automotive History Collection at the Detroit Public Library.)

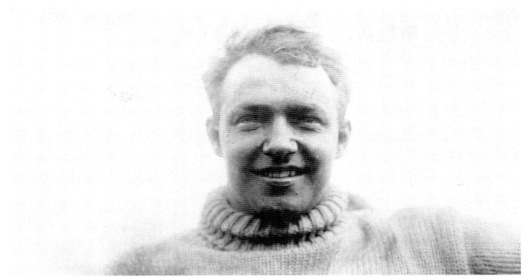

After his 1908 Vanderbilt Cup Race victory, George Robertson was considered by many to be America's premier race driver. Only weeks earlier he had scored impressive stock car victories driving a Simplex in the 24-hour race at the Brighton Beach track and then in a Locomobile 40 at Fairmount Park in Philadelphia. His driving career was cut short while practicing for the 1910 Vanderbilt Cup Race when a newspaperman riding with him to develop a story panicked and clutched the driver as he entered a sharp turn. Robertson suffered injuries to his right arm that made it impossible for him to drive the heavy cars of the day in competition. (Courtesy of the National Automotive History Collection at the Detroit Public Library.)

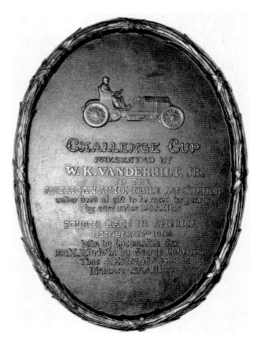

Collectibles and memorabilia from the Vanderbilt Cup Races have turned up in auctions, in flea markets, and on the Internet throughout the years. The rarest items are the 22 oval bronze plaques produced by Tiffany and Company from 1904 to 1916. The race sponsors produced two plaques for each race that were presented to the winning driver and manufacturer. Until 1910, when $2,000 was awarded to the winner, the plaque was the only official award and compensation given by the sponsors to the driver for winning the Vanderbilt Cup Race.

VANDERBILT CUP RACES OF LONG ISLAND

Bridgeport, Connecticut, where the Locomobile was manufactured, declared Monday, November 9 a holiday as George Robertson paraded the victorious No. 16 Locomobile around town before 30,000 spectators. That evening more than 300 business and community leaders attended the largest banquet in the city's history up to that time in the dining room of the new Stratfield Hotel. The Vanderbilt Cup was proudly displayed in the back of the room. Silver four-inch toasting cups made in the likeness of the Vanderbilt Cup were distributed by Locomobile to celebrate the victory.

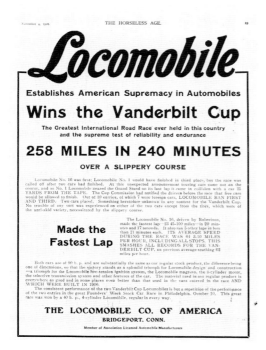

Although the Locomobile Company promoted the establishment of "American Supremacy in Automobiles" in its advertisements, it soon decided to discontinue its racing efforts due to its expense. The Locomobile Company continued to prosper through World War I, when it received several lucrative military contracts. But changes in the market and company management forced it to struggle through the 1920s before eventually closing its doors in March 1929.

7

THE 1909 VANDERBILT CUP RACE

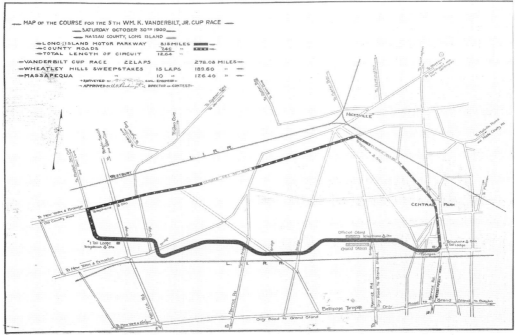

At 12.64 miles, the 1909 course was shorter than those for any previous Vanderbilt Cup Race and for the first time did not cross railroad tracks. The Long Island Motor Parkway made up 5.15 miles of the total distance. Organizers believed the shorter course would decrease the intervals of time between appearances of cars and also provide more exciting entertainment for spectators. The 1909 race was held on October 30, later in autumn than any other Vanderbilt Cup Race. The race began at 9:00 a.m. rather than the traditional daybreak start. The late start and colder weather of the later date were cited as reasons for a precipitous decline in attendance from previous years.

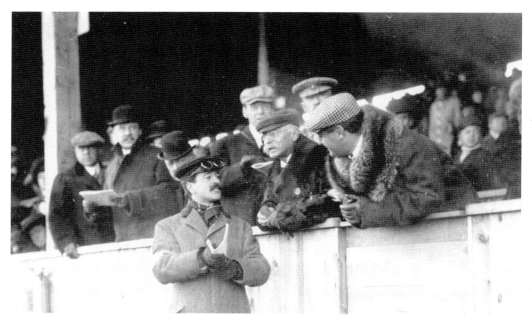

Referee William K. Vanderbilt Jr. finds time on race morning to connect with friends in the grandstand. The grandstand box seats were always occupied with many of his family, friends, and people of prominent social position. (Courtesy of the Helck family collection.)

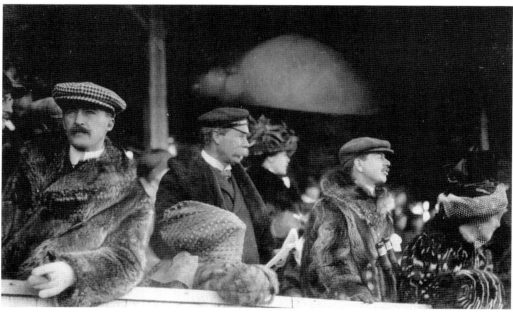

Sir Thomas Lipton (center with his distinctive mustache), founder of Lipton Tea and knighted by Queen Victoria in 1898, was one of the most prominent spectators at the 1909 race. Lipton shared a passion for yachting with the Vanderbilts and competed for the America's Cup yacht race on several occasions. (Courtesy of the Helck family collection.)

December-like weather exacerbated by relentless galelike winds discouraged attendance at the race. While the event had drawn numbers approaching 200,000 people in 1906 and 1908, the *New York Times* estimated that only 75,000 were on hand in 1909. Water pipes in the pits froze overnight, and the cold forced those present to wear Artic-style, thick fur coats. (Courtesy of the Keystone-Mast Collection, UCR/California Museum of Photography, University of California, Riverside.)

Dave Hennen Morris (left), president of the ACA, donned a thick fur coat, gloves, and Siberian-style cap as he approached the grandstand. Morris married Alice Vanderbilt Shepard, the sister of the 1906 Vanderbilt Cup racer Elliot Shepard Jr. and a cousin of William K. Vanderbilt Jr. From 1933 to 1937, he was U.S. ambassador to Belgium and envoy to Luxembourg. (Courtesy of the Keystone-Mast Collection, UCR/California Museum of Photography, University of California, Riverside.)

Warm coffee was served at the 1909 race in thermos bottles from a truck designed especially for the American Thermos Bottle Company. Insulated thermos bottles were first manufactured in the United States in Brooklyn in 1907. (Nassau County Department of Parks, Recreation and Museums–Cedarmere.)

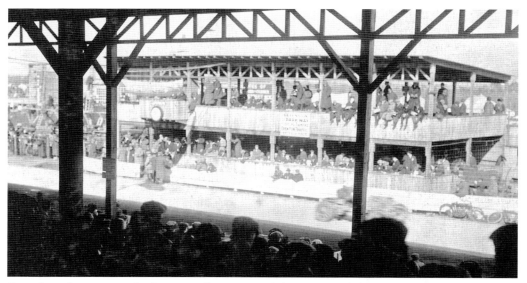

Grandstand spectators had an excellent view of the action taking place on the Long Island Motor Parkway. Across the road was the two-level press and officials stand, which served as a hub for the event. Telephone reports were called in from around the 12.64-mile course so officials could update the scoreboard and announcer Peter Prunty could shout news through his giant megaphone to the gathering. (Courtesy of the National Automotive History Collection at the Detroit Public Library.)

Disappointed driver Harry Stillman sits beside his disabled No. 12 Marmon racer after his radiator cracked during lap 7 on the Long Island Motor Parkway. (Courtesy of the National Automotive History Collection at the Detroit Public Library.)

Harry Grant's No. 8 Alco moved into second place as he passed under a Long Island Motor Parkway bridge during lap 15. The bridge was located in the Hempstead Plains in an area now filled with Levittown homes. (Courtesy of the National Automotive History Collection at the Detroit Public Library.)

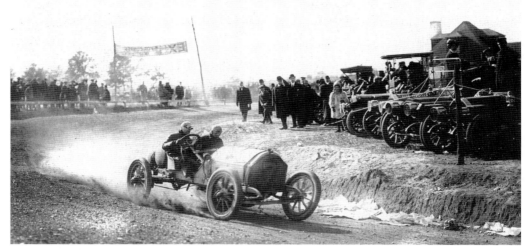

The No. 7 Chalmers-Detroit driven by Billy Knipper skids through the Massapequa turn just after the end of the Long Island Motor Parkway portion of the course. The building in the background was the Massapequa Lodge, one of the three toll lodges built in 1908 to collect fares when the public used the Long Island Motor Parkway. The banked turn was part of a temporary road built especially for the race to connect the exit of the motor parkway with northbound Massapequa-Hicksville Road. (Courtesy of Brown Brothers.)

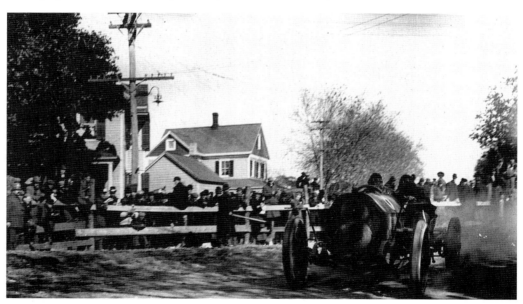

Driver Harry Grant in his No. 8 Alco speeds through the Hicksville turn, which was at the intersection of Broadway and Old Country Road. Located in one of the more heavily populated areas of Nassau County, this turn attracted a great deal of interest because of its potential to produce accidents and its proximity to the Hicksville railroad station. As with the Massapequa turn, the Hicksville turn was banked slightly for safety. (Courtesy of Brown Brothers.)

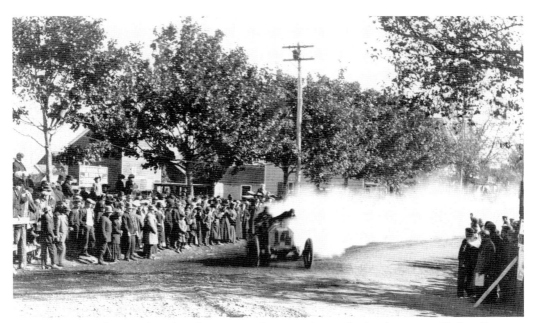

The No. 14 Fiat driver Edward Parker was on the gas as he made the dangerous Hicksville turn. Parker's mechanician leaned out of the car toward the inside of the corner as ballast to balance the racer and mitigate the risk of turning over. (Courtesy of the Helck family collection.)

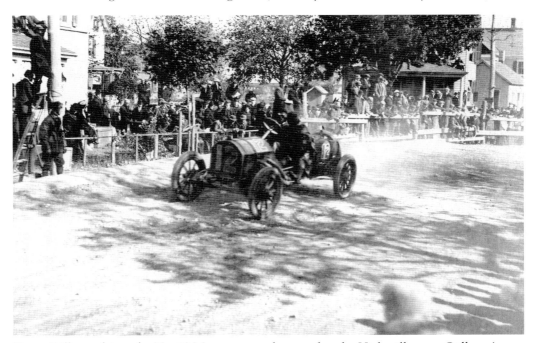

Harry Stillman drives the No. 12 Marmon past the crowd at the Hicksville turn. Stillman's race ended early when his radiator cracked on lap 7. (Courtesy of the National Automotive History Collection at the Detroit Public Library.)

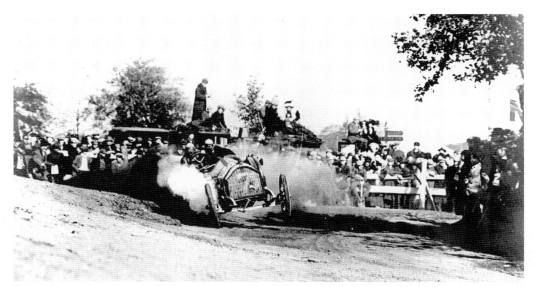

Driver Billy Knipper in his No. 7 Chalmers-Detroit "Blue Bird" narrowly averted disaster at the Westbury turn at Old Country Road and Ellison Avenue. Knipper led the race for 12 laps and looked like a sure winner until an engine bearing seized on lap 20. The primitive suspensions and inherently high center of gravity in cars of the era presented challenges when rounding corners at high speed. (Courtesy of the Helck family collection.)

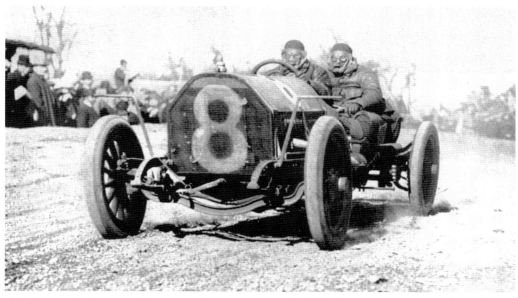

Widely regarded as one of the more dangerous turns, the Westbury turn attracted a large throng of people, many unwisely lining the course and clearly in harm's way. The turn was banked on its west side in an effort to assist cars from skidding off the course. Full-face hoods are worn by both driver Harry Grant and his mechanician Frank Lee in their Alco to protect them from dust and stones.

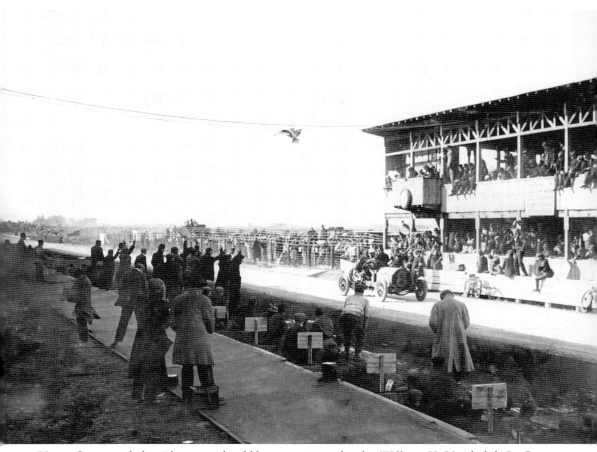

Harry Grant and the Alco won the fifth competition for the William K. Vanderbilt Jr. Cup. Only 2 of 15 starters completed the race, Grant and the Fiat driven by Edward Parker, who finished 5 minutes and 16 seconds behind the winner. The Alco, the only six-cylinder car in the race, had survived a torturous test. In the convention of the day, all other cars had four-cylinder engines. The press was not kind in evaluating this stock car version of the Vanderbilt Cup Race. The *Motor World*, of the trade press, said, "It was to the old time Vanderbilts as the maligned lemon is to the delicious grapefruit." (Courtesy of the National Automotive History Collection at the Detroit Public Library.)

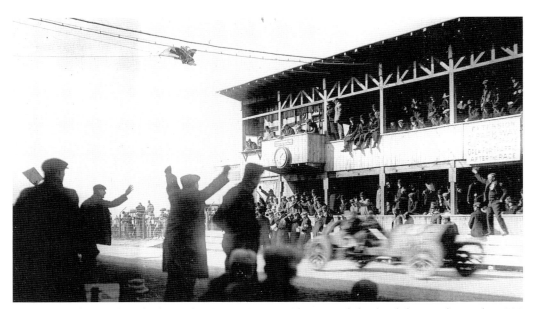

Pit crews and race officials cheered as Harry Grant's Alco passed the finish line and won the 1909 Vanderbilt Cup. Grant achieved an average speed of 62.8 miles per hour for the 278.08 miles. This speed was faster than all the previous Vanderbilt Cup Races with the exception of George Robertson's 1908 victory at 64.38 miles per hour. (Courtesy of the Helck family collection.)

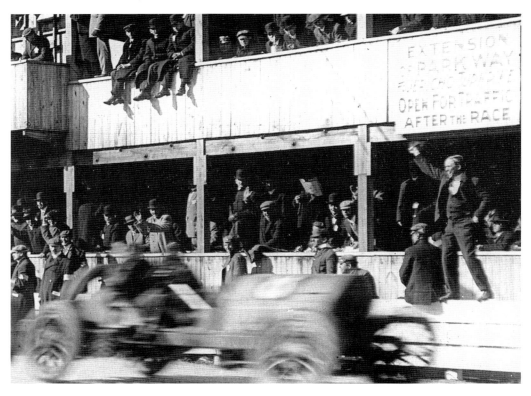

8

The 1910 Vanderbilt Cup Race

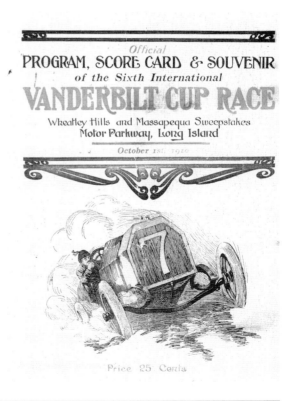

The 1910 Vanderbilt Cup Race was held on October 1 on the same course configuration as the 1909 race. This was the only time the race was run on the same course as the previous year. Two weeks after the Vanderbilt Cup Race, the 1910 Grand Prize Race was also scheduled to be held there. The AAA and ACA had formed the Motor Cups Holding Company, which established the ACA as the sanctioning body for international contests and the AAA for national events. The agreement called for the holding company to organize both races.

Responding to the precipitous decline in public interest in the Vanderbilt Cup Race in 1909, race officials returned to a daybreak start in 1910. This triggered the kind of all-night revelry the event had became famous for, jamming Long Island hotels beyond capacity. Many people chose to sleep under the stars—or to not sleep at all.

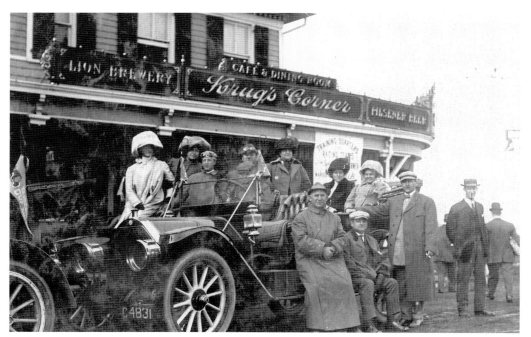

Approximately two miles from the 1910 course, Krug's Hotel was still a great place for friends to gather, swap stories, and leave in groups for choice vantage spots around the course. (Courtesy of the National Automotive History Collection at the Detroit Public Library.)

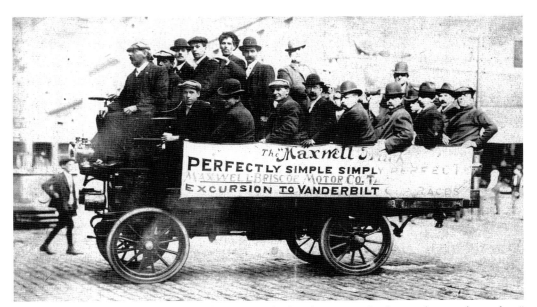

Maxwell, an early automobile manufacturer with the slogan "perfectly simple, simply perfect," provided a bus for an "excursion to Vanderbilt Cup Races."

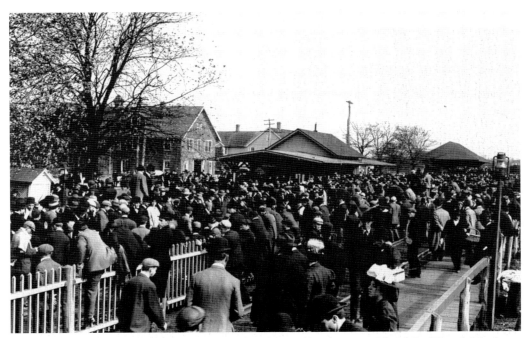

As in previous years, most spectators arrived to the race by the Long Island Rail Road. The huge crowd at the Westbury train station showed increased interest in the event over the 1909 race. The *New York Times* estimated the overall crowd was 275,000. Other estimates ranged from 100,000 to a half million. (Courtesy of Brown Brothers.)

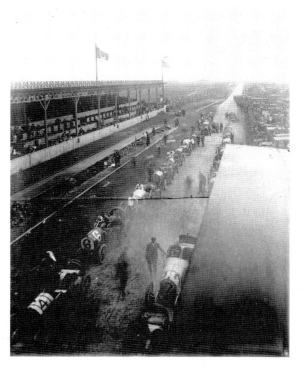

The starting formation for the race was shown from atop the double-deck press and officials stand where a bugler blew horn blasts as cars came into view. Starter Fred Wagner lined up odd-numbered cars to the inside of the course and even-numbered cars to the outside. Just to the left of the row of cars were the sunken pits where crews huddled with supplies. (Courtesy of the George Eastman House.)

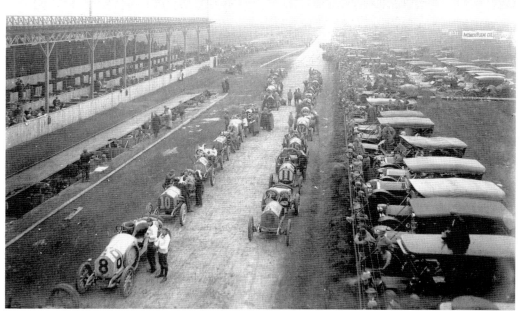

A row of touring cars parked at the inside of the course on the right at the start of the race. These were prized parking spots as many people viewed the race from their cars. (Courtesy of the George Eastman House.)

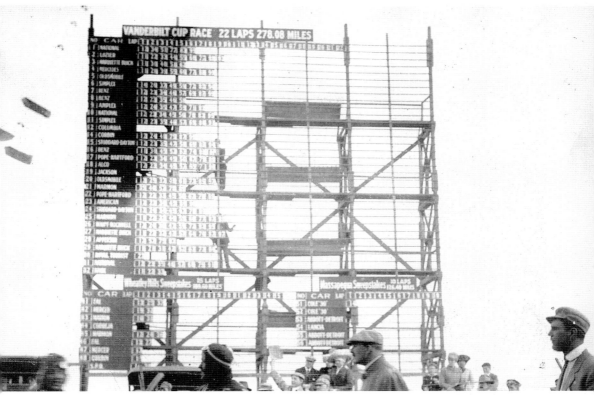

Thirty cars started in the 1910 race, the largest number ever for a Vanderbilt Cup Race. Each car needed to complete 22 laps of the 12.64-mile course for a total of 278.08 miles. In addition, two races were also run simultaneously for smaller, commercially available stock cars. The Wheatley Hills Sweepstakes had eight starters and was set for 15 laps or 189.6 miles. The Massapequa Sweepstakes had six starters for smaller stock cars and was scheduled for 10 laps or 126.4 miles. At the grandstand, officials used a large yet virtually unreadable scoreboard to track the progress of the 44 cars participating in the three races. (Courtesy of the National Automotive History Collection at the Detroit Public Library.)

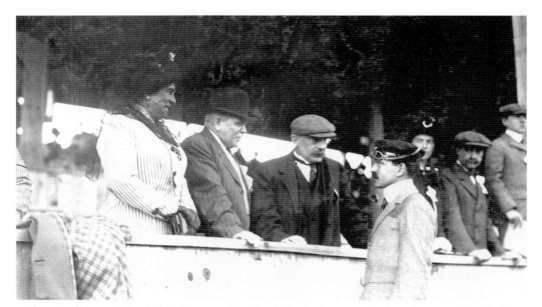

Referee William K. Vanderbilt Jr. greets his friends in the box seats before the race. The clothing worn illustrates the more hospitable weather in 1910 compared to the winterlike weather of the previous year. (Courtesy of the National Automotive History Collection at the Detroit Public Library.)

A pit crew awaits a call to action. Each pit was five feet deep and stocked with tools and supplies to keep each car running smoothly during the race. In a change from previous Vanderbilt Cup Races where only the driver and riding mechanician were allowed to work on the car, new rules for 1910 allowed two of the pit crew to assist as well. However, this assistance was limited to the replenishment of water, oil, and fuel and the replacement of tires. These crew members could also crank start the car. (Courtesy of the National Automotive History Collection at the Detroit Public Library.)

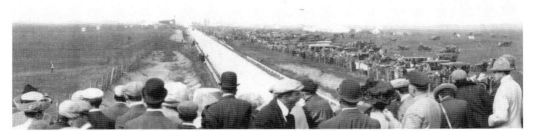

The bridges over the Long Island Motor Parkway were popular vantage points for spectators to view the race. The Jerusalem Avenue Bridge was about a half mile east of the grandstand, which could be seen on the horizon. (Courtesy of the National Automotive History Collection at the Detroit Public Library.)

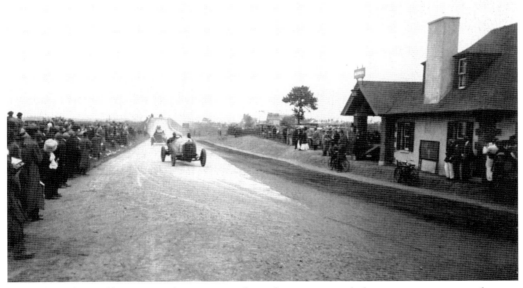

The relatively small course and greater number of entries provided many opportunities for cars to compete. The No. 16 Benz driven by David Bruce-Brown pulled ahead of the No. 9 Amplex driven by Walter Jones as they approached the Massapequa Lodge. The bridge over Wantagh Avenue was approximately one-eighth of a mile to the west in the background. (Courtesy of Brown Brothers.)

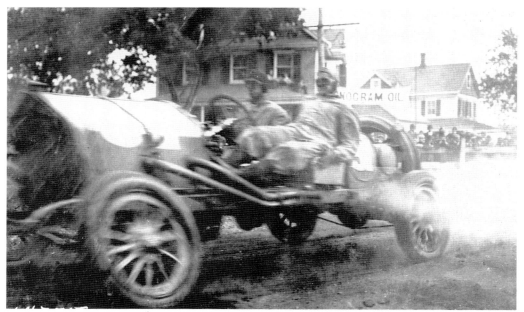

Richard Albrecht, the mechanician for Louis Disbrow's No. 31 National, is hanging on with all his strength at the Hicksville turn. Disbrow finished fourth behind teammate Johnny Aitken in third. A Monogram Oil banner stretched between the houses in the background demonstrates the early commercial opportunities for automobile racing. (Courtesy of the National Automotive History Collection at the Detroit Public Library.)

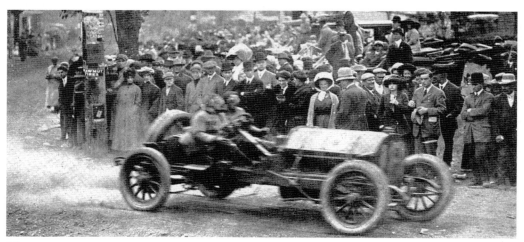

The 1909 winner, Harry Grant drove another steady race, taking advantage of the accidents and mechanical failures of other competitors. The crowd is dangerously close to the cars at the turn at Old Country Road and Ellison Avenue in Westbury. (Courtesy of the National Automotive History Collection at the Detroit Public Library.)

Early leader Louis Chevrolet's race ended on lap 16 in spectacular if inglorious fashion with his Marquette-Buick upside down near the front porch of a Hicksville home at Old Country Road. Chevrolet dominated the race in the early stages with his third lap the fastest of the race at 75 miles per hour. (Courtesy of the Helck family collection.)

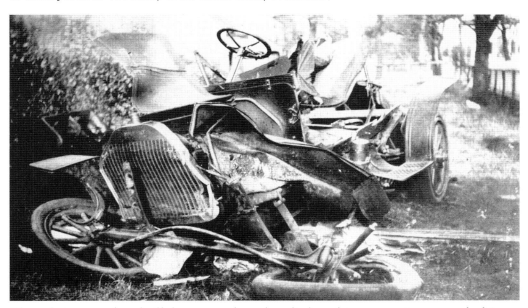

Chevrolet's car rocketed off the course through a ditch and into a touring car parked in an adjacent yard. Three women were in the car (shown above), and amazingly none were seriously injured. Chevrolet was thrown clear of the accident, the fall inflicting a broken arm but no life-threatening injuries. However, his mechanician Charles Miller was pinned under the heavy racer and died on the scene. (Courtesy of the Helck family collection.)

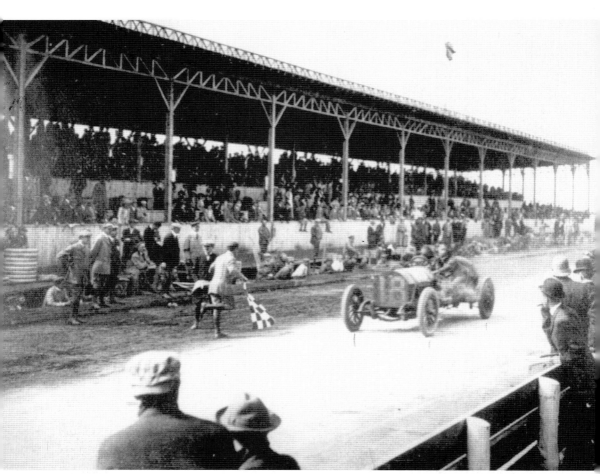

Starter Fred Wagner waves the checkered flag as the No. 18 Alco storms by to win the 1910 race. The final lap was full of the drama of a classic Vanderbilt Cup Race. Grant was struggling to hold off 21-year-old Joe Dawson, also known as "the Indiana Whirlwind." After Louis Chevrolet's car retired, Dawson had the fastest car, pulling out a lead of more than four minutes on Grant by lap 17. But the poor judgment of a spectator who was hit by Dawson on the backstretch during the next lap determined the outcome of the race. Dawson stopped to check on the man, who suffered two broken legs, and then had to pit to repair his gas line. He spent the remaining four laps steadily gaining on Grant only to come up 25 seconds short.

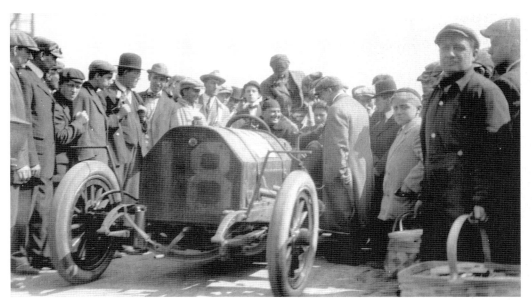

Driver Harry Grant's winning average speed was 65.1 miles per hour, the fastest time ever for a Vanderbilt Cup Race. He completed the 278 miles in 4 hours, 15 minutes, and 58.34 seconds. After the race, spectators swarmed his car at the grandstand. (Courtesy of the George Eastman House.)

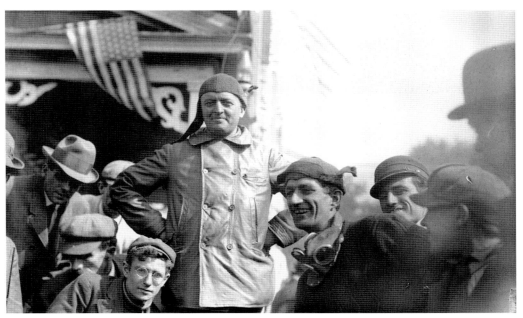

Grant (center) and mechanician Frank Lee (to the left of Grant in the foreground) pose with admirers after taking the Vanderbilt Cup Race for the second consecutive year. Grant used the same Alco—certified by officials after the race as a stock car—in both his victories. (Courtesy of the George Eastman House.)

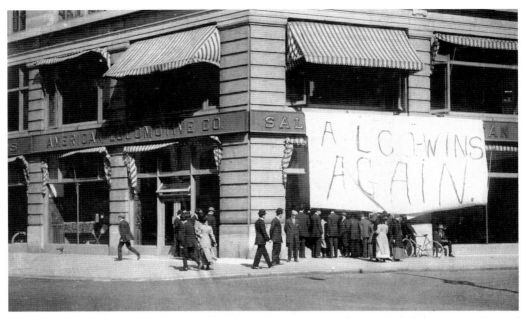

The American Locomotive Company celebrated its victory with a makeshift banner in front of the company's New York City sales showroom, proclaiming "Alco Wins Again." (Courtesy of the National Automotive History Collection at the Detroit Public Library.)

American Locomotive Company promoted the victory of the Alco as "an unequalled performance by an unequalled car." It was one of many manufacturers to advertise its success in the 1910 Vanderbilt Cup Race to attract customers. Marmon, Oldsmobile, Cole, Pope-Hartford, and Abbott-Detroit ran impressive advertisements touting various achievements of their cars during the Vanderbilt races.

PRESENTING THE CUP.
—Macauley in the New York *World*.

During the 1910 race, two mechanicians were killed and several spectators were injured. In addition to Charles Miller, Chevrolet's mechanician, Matthew Bacon, the mechanician for driver Harold Stone, was killed in a first-lap accident when their Columbia car leaped over the Newbridge Avenue Bridge in East Meadow. Much of the press leveled criticism of reckless disregard for human safety at the race management. The *New York World*'s scathing editorial cartoon of the grim reaper presenting the Vanderbilt Cup to the winning Alco was an example of some of the more sensationalist coverage that proliferated in the age of yellow journalism.

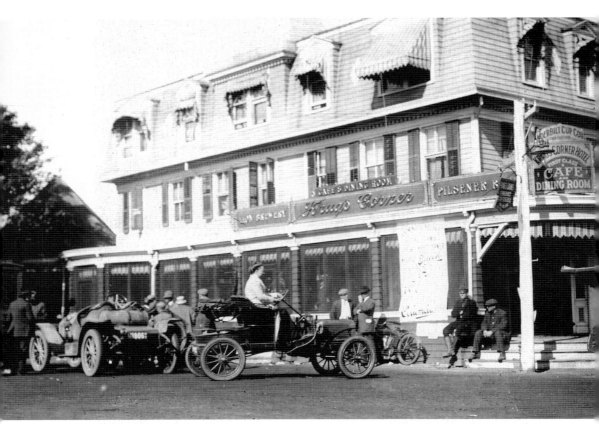

While newspapers and trade journals criticized the race, it was the entrants who stood in solidarity to put an end to the Vanderbilt Cup Races on Long Island. On October 5, 12 of the manufacturers met at Krug's Hotel and appointed a committee to represent their position to the Motor Cups Holding Company officials. On the following day, the committee for the entrants met at the ACA offices in New York to discuss their position with race officials. Hours of debate ensued, but it eventually became clear to everyone that after six years of controversial races, the sport had outgrown the venue. The deaths and injuries of the 1910 race put an end to road racing on Long Island.

From 1911 to 1916, the Vanderbilt Cup Race moved around the country: Savannah (1911), Milwaukee (1913), Santa Monica (1914), San Francisco (1915), and back to Santa Monica (1916). Interviewed by the New York Times on October 7, 1934, on the 30th anniversary of the first Vanderbilt Cup Race, William K. Vanderbilt II reflected, "I had done a great deal of motoring abroad, and had seen the effect of racing competitions on the foreign cars. Foreign cars then seemed to be always about 5 years ahead of the American cars. If something could be done to induce the foreign makers to race in this country, our manufacturers would benefit by it . . . We kept on racing for a number of years on Long Island. After the races in Savannah, Milwaukee and San Francisco, the cup was withdrawn from competition following the final race in Santa Monica in 1916." The reporter then asked, "It just didn't seem like the Vanderbilt Cup Race when it was taken away from Long Island, did it, Mr. Vanderbilt?" Vanderbilt responded, "No. And it did seem that all that could be hoped for had been accomplished, so it was a fitting moment to end the races."

Across America, People are Discovering Something Wonderful. Their Heritage.

Arcadia Publishing is the leading local history publisher in the United States. With more than 3,000 titles in print and hundreds of new titles released every year, Arcadia has extensive specialized experience chronicling the history of communities and celebrating America's hidden stories, bringing to life the people, places, and events from the past. To discover the history of other communities across the nation, please visit:

www.arcadiapublishing.com

Customized search tools allow you to find regional history books about the town where you grew up, the cities where your friends and family live, the town where your parents met, or even that retirement spot you've been dreaming about.